IMAGES
of Rail

Roanoke Locomotive Shops and the Norfolk & Western Railroad

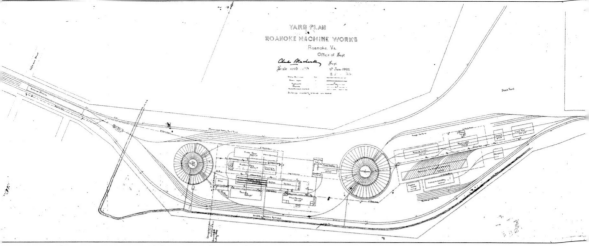

This June 9, 1882, blueprint shows the original layout of Roanoke Machine Works (RMW). The Norfolk & Western main line was moved so that it ran south of the complex, while the Shenandoah Valley Railroad came in from the north. The facility was located on the salt lick, which gave Big Lick its name; the bog had to be drained and filled. (JG.)

ON THE COVER: This c. 1917 photograph of Roanoke Shops shows a pedestrian bridge, which provided employees access to the shops. The Shenandoah Division main line tracks are in the foreground, and behind them, on the right, is the framework for a tender under construction. Locomotive repairs were done in the roundhouse. The various shops are located in the buildings behind. (Norfolk & Western Historical Photograph Collection, Norfolk Southern Archives.)

IMAGES *of Rail*

ROANOKE LOCOMOTIVE SHOPS AND THE NORFOLK & WESTERN RAILROAD

Wayne McKinney

ARCADIA
PUBLISHING

Published by Arcadia Publishing
Charleston, South Carolina

Printed in the United States of America

Library of Congress Control Number: 2013946232

For all general information, please contact Arcadia Publishing:
Telephone 843-853-2070
Fax 843-853-0044
E-mail sales@arcadiapublishing.com
For customer service and orders:
Toll-Free 1-888-313-2665

Visit us on the Internet at www.arcadiapublishing.com

This book is dedicated to the employees of Norfolk Southern and particularly to the skilled craftsmen at Roanoke Locomotive Shops.

CONTENTS

ACKNOWLEDGMENTS

When I began this project, I approached the manager of Roanoke Locomotive Shops, Chuck Sloan, for his input and would like to thank him for his encouragement and help. I would also like to thank assistant shop manager Jeff Cutright for his feedback while reviewing the last two chapters of the book. I could not have done it without the more-than-helpful Jennifer McDaid, Norfolk Southern's archivist. She waded through long lists of photograph requests and got the photographs to me in a timely manner. William Harmon's collection was invaluable, especially when documenting the various locomotives featured in chapter 4. His photographs were made available to me by Nathan Kidd, his grandson.

I would also like to thank the Norfolk & Western Historical Society (NWHS) for their help. Their archives are an invaluable resource, and the individual members are more than willing to help researchers find specific information among the thousands of books, documents, and photographs they house. I would especially like to thank Ron Davis for his help and suggestions. Also thanks to Louis Newton, Bud Jefferies, Ed King, Jim Nichols, Mason Cooper, and Ken Miller, who took the time to review the chapters for any historical inaccuracies.

Finally, I would like to thank my family for their help and support. My daughter Kristy Ramsey and daughter-in-law Dawn McKinney provided a woman's perspective, leading me to reevaluate the way some of the information is presented. My brother Jerry McKinney and his wife, Judy, provided help every step of the way, from proofreading to final layout.

The photographs in this book come from a variety of sources, including Norfolk & Western Historical Photograph Collection, Norfolk Southern Archives in Norfolk, Virginia (NS); VT ImageBase (imagebase.lib.vt.edu), housed and operated by Digital Library and Archives, University Libraries, and scanned by Digital Imaging, Learning Technologies, Virginia Tech (VT); William Harmon collection, courtesy of Nathan Kidd (NK); lithograph drawings from the September 9, 1891, edition of the *Roanoke Daily Times* (RT); Norfolk & Western Historical Society (NWHS); author's collection (WM); author's collection, originally donated by Jim Gillum (JG); and other sources have been cited accordingly.

INTRODUCTION

Today, Roanoke is a thriving, Southern city with a variety of businesses, including one of the most modern biomedical facilities anywhere. In today's fast-paced climate, it is easy to forget that Roanoke was once a railroad town, and without the railroad, Roanoke would not exist.

In February 1881, Roanoke was the sleepy village of Big Lick, with a population of 400 to 600 people. E.W. Clarke & Company had just formed the Norfolk & Western Railroad (N&W) out of the old Atlantic, Mississippi & Ohio. It also owned the Shenandoah Valley Railroad (SVRR), where Fredrick J. Kimball served as president. Kimball was appointed first vice president and chief operating officer of the N&W, and his first decision was to find a suitable site for a juncture of the two railroads he served.

Soon, the citizens of Big Lick saw engineers surveying and checking out sites in Montvale, Bonsack, Big Lick, and Salem. When people heard that the board of directors of the SVRR was to meet in Lexington to make a final decision on where to intersect with the N&W, they took action. Local businessmen gathered $10,000 in pledges and papers guaranteeing free right-of-way from Cloverdale to Big Lick. When a rider delivered these items to the meeting, Kimball is said to have remarked, "The people of Big Lick are alive and at Big Lick the Shenandoah would have friends."

Growth in the Roanoke Valley began almost immediately. By June 1882, the N&W, or its subsidiaries, had constructed 78 frame houses and 60 brick houses. Another 62 houses were proposed, but there were not enough contractors to build them. Enterprising individuals had erected a mill, 2 office buildings, 15 stores, and 7 residential homes. By mid-1882, less than a year since it was decided to join the two roads there, the population had grown to 3,000. It would reach 5,000 by 1883, and shortly afterward, 10,000. Seeing their village grow to a town, and soon a city, the citizens decided they needed a more euphonious name for their community, and in 1882, the name was changed from Big Lick to Roanoke.

The growth spurt can be directly attributed to the Roanoke Machine Works (RMW), where work had already begun. "The Works," as originally constructed, consisted of a smith shop, machine shop, machine shop annex, engine erecting shop, foundry, planing mill, lumber dryer, storehouse, engine roundhouse for 22 engines, and car roundhouse with 21 stalls. The cost of the entire complex, as equipped for operation, was $879,937.66. Production for the entire complex was 8 to 10 cars per day and 3 engines per month.

Aside from the presence of the railroad, the city offered incentives to businesses and industries to locate in the area, including free land and no taxes for a period of 10 years. While successful in encouraging industrial growth, the incentives left the new city with an insufficient tax base to support the rapid population growth. For the first 10 years of its existence, Roanoke was plagued with muddy streets, wooden sidewalks, poor street lighting, and, worse, open sewers and bad drainage.

But by 1895, a general business downturn and the continued expansion of the N&W had forced the railroad into receivership. On March 27, 1895, receivers took over the operation of the RMW.

In 1897, the railroad was reorganized into the Norfolk & Western Railway and incorporated the SVRR and the various extensions that had been built before the company went into receivership. As part of the reorganization, the Roanoke Machine Works was also incorporated into the company and became Roanoke Shops of the Norfolk & Western Railway.

Production slowed for the next two decades as shop facilities were rebuilt to equip them to build the larger and more powerful locomotives. The locomotives that were produced were designed to fill specific needs of the company, as N&W designers were gaining a better understanding of the kinds of locomotives needed on their system.

With the various shops rebuilt, the entire facility was equipped for efficient production of any locomotives that could be designed by the motive power engineers. That was proven in 1936, with the design of the 2-6-6-4 Class A, which some consider the finest steam locomotive ever built. The first two of this class were completed in May and June 1936. They were immediately followed by five Y6s. These were 2-8-8-2s of N&W's own design and were considered the best of this type. Eventually, many earlier "Ys" were converted to this configuration.

Production of the 4-8-4 Class J began just prior to America's entry into World War II and continued into early 1942. Throughout the 1940s and into the early 1950s, the shops alternated in the production of these three classes, eventually producing 81 Class Y6 (including the "a" and "b" variations), 43 Class A, and 14 Class J locomotives. These are referred to as the "Magnificent Three" and are considered the ultimate in steam locomotive design. When production of the Y6s ended in 1952, diesel locomotives were making heavy inroads into the rail industry. Even though N&W was strongly committed to steam, the advantages of diesel power were too obvious to ignore, and comparisons of steam and diesel power were made in 1952. In 1953, the last steam locomotives were constructed in Roanoke Shops. Thirty 0-8-0 switch engines, designated Class S1a, brought an end to a magical era.

The introduction of diesels brought hard times to all rail maintenance facilities, and if not for freight car production, the shops might have closed completely. As it was, the locomotive workforce was drastically reduced. Men who had highly developed skills soon found their skills were no longer needed. However, those who remained learned and adapted to the new form of motive power. They became experts in its maintenance, often developing solutions and practices that were adopted by diesel manufacturers.

The railroad shops at Roanoke have existed under three different names. Incorporated as the Roanoke Machine Works, it became Roanoke Shops. That name encompassed both the locomotive and car departments. Unfortunately, there was not enough space in the book to cover car production and repair. That work ceased in 2000, and when it did, the term Roanoke Locomotive Shop(s) became the common way to refer to the facility. You will see it called by all names at appropriate times in this narrative. In all cases, the reference is to a shop filled with skilled craftsmen who take great pride in their work.

This book outlines the history of Roanoke Shops in detail, concentrating on the glory days of steam and the city that grew and prospered with them. The photographs show skilled, rugged, and hardworking men doing jobs they love. But the history of Roanoke Shops did not end with steam. Although the shops are no longer the major employer they once were, Roanoke Locomotive Shop(s) (RLS) still makes a major contribution to Norfolk Southern Corporation. Those contributions are outlined in the final chapters and are illustrated by many photographs that have never been seen before. The future looks bright. New doors are opening, and more glory days lie ahead. Roanoke Shops will continue to have an influence in the "Magic City" for a long time to come.

One

BEGINNINGS

In 1881, citizens of the hamlet of Big Lick noticed railroad surveyors in the area and learned there was to be a meeting in Lexington, Virginia, to decide on the location of a juncture between the Shenandoah Valley Railroad (SVRR) and the Norfolk & Western Railroad (N&W). Local businessmen, including familiar names such as Trout, Terry, Jamison, Fishburne, Rorer, and McClanahan, collected $10,000 and pledges of free right-of-way in attempt to lure the railroad to Big Lick. The incentives were entrusted to a rider who passed them on to John Moomaw, and they achieved their desired results.

Aside from joining the two roads, Fredrick J. Kimball also wanted to meet the companies' needs by building a maintenance facility large enough to supply both railroads. By October 1881, construction of Roanoke Machine Works (RMW) was under way, and by July 1, 1883, RMW was able to begin repairing existing equipment. By the end of the year, work had begun on its first new locomotive, a Class I, 2-8-0 "Consolidation" freight locomotive. This unit went into service in September 1884.

In its first 10 months of operation, RMW built 673 gondola cars and 386 boxcars and their capacity reached eight cars per day. The locomotive department turned out their first new locomotive in July 1884, and eight others were under construction. In addition to newly built equipment, they repaired 91 locomotives, 289 freight cars, and 21 passenger cars.

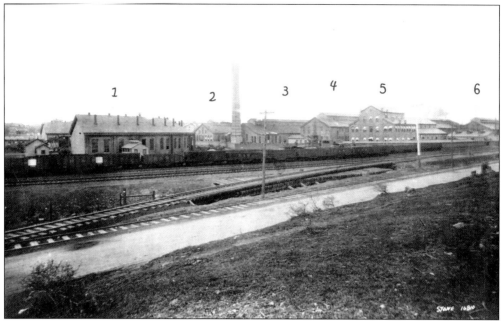

The original shop complex is shown in this very early photograph. The buildings are 1) roundhouse, 2) blacksmith shop, 3) machine shop, 4) erecting shop, 5) motive power office building and general storehouse, and 6) car wheel foundry. Campbell Avenue is in the foreground; the photograph was taken from the hillside opposite, approximately where a convenience store now stands. (NS.)

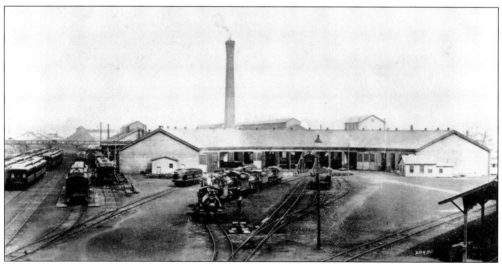

This early photograph shows the locomotive roundhouse at the west end of the complex around 1897. In the background is the smokestack at the end of the machine shop, the blacksmith shop is behind the left side of the roundhouse, the erecting shop is at the center and behind the smokestack, and the motive power and storehouse building peeks over the roundhouse at center right. (VT.)

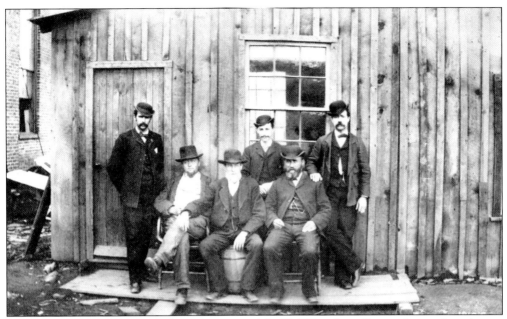

This 1882 photograph shows early construction of the RMW, its first office, and several employees. From left to right are Doc Harris (clerk), Robert Hayward (brick layers foreman), C.O. Vedder (machine shop foreman), George McCahan (timekeeper), James Dickson (master mechanic), and G.F. Fraser (chief clerk). (NS.)

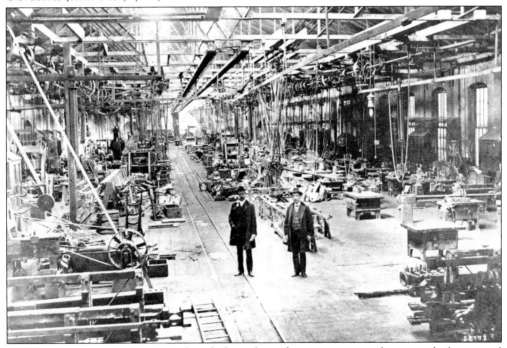

In this c. 1885 photograph, two unidentified members of management are shown inside the original machine shop. The building measured 72 feet wide by 381 feet long and was draped from one end to the other with drive belts. These belts hung from shafts in the ceiling, which were turned by a steam engine at the end of the building. The belts drove the individual machines. (NS.)

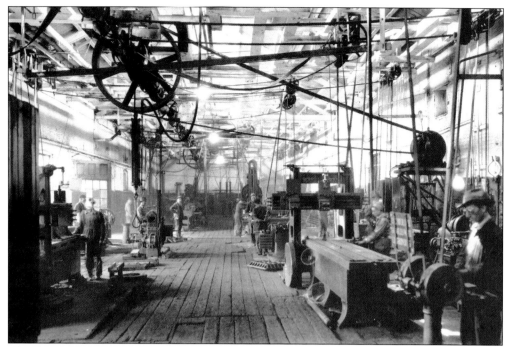

The shop had begun to convert to electricity by the time this photograph was taken. Although the machines are still belt-driven, the shaft is driven by a large electric motor in the center right. There are also electric lights visible in the ceiling. Note the nearly "headless" man at the extreme left, a result of camera exposure limitations. (JG.)

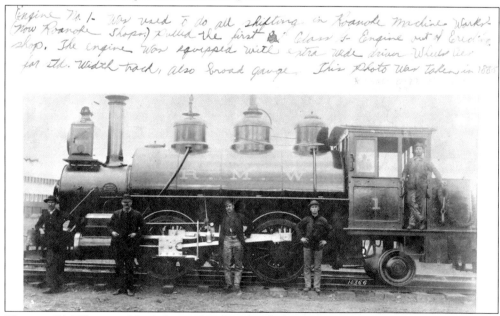

This was RMW engine No. 1. It was "used to do all the shifting in Roanoke Machine Works," according to the original caption above. The original caption also states that it was equipped with extra-wide drivers so it could work on both standard- and wide-gauge track. After 1897, it was reclassified as a Class O-27 and renumbered No. 27. (VT.)

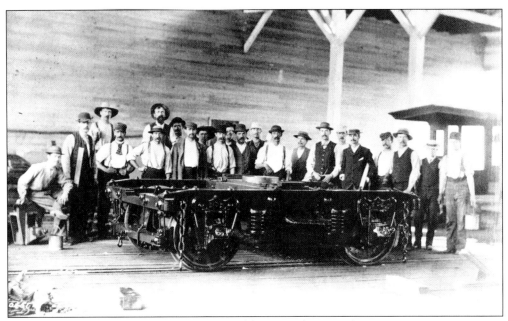

Construction of the shops began in 1881, and by 1883, they were beginning to service existing locomotives and equipment from both the Shenandoah Valley Railroad and the Norfolk & Western. Although the first locomotive was not produced until 1884, some new equipment was being turned out, and this photograph shows the men of the passenger car shop posing with the first truck they produced in 1883. (NS.)

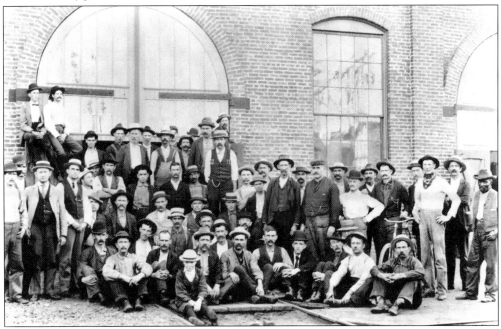

Another photograph of the passenger car shop employees features about 60 men. Their dress and appearance indicate the photograph was taken in the same era as the previous one. Both the passenger car shop and freight car shop were located in the east roundhouse. Note the young boy at the front left. (NS.)

These dirty, rough-looking men comprise the Roanoke Machine Works Safety Committee. Today, it is hard to comprehend how dangerous railroad work once was. To illustrate, the Interstate Commerce Commission's Accident Bulletin for the third quarter, in 1901, reported 615 railroad employees killed and 8,361 injured nationwide. This group demonstrates N&W's early interest in employee safety. (VT.)

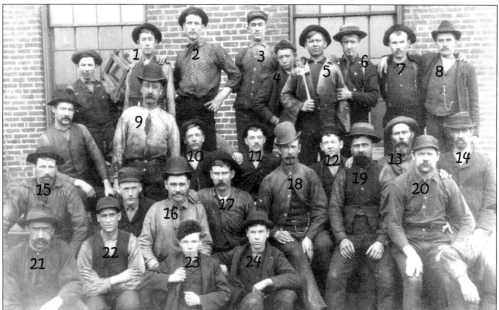

Some early RMW employees are 1) Dennis O'Leary, 2) Tom Wilkerson, 3) Johnny Burchet, 4) Jake Boyd, 5) Ruben Frayman (later Dr. Frayman), 6) John Boyd, 7) Jim Humphries, 8) W.H. Neff, 9) Captain Buckner (first N&W conductor), 10) Jim Burchet, 11) Tom Rose Jr., 12) Henry Burchet, 13) Tom Rose Sr., 14) Henry Spangler, 15) J.H. Wigmore, 16) Jim Watts, 17) Bob Layne, 18) Jim Wigmore, 19) W.L. McLelland, 20) Ed McCarty, 21) Charles Griffith, 22) Lonnie Eades, 23) Will Humphries, and 24) Bill Dillon. (NS.)

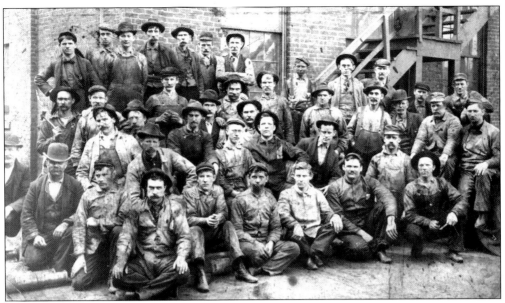

This is a photograph of the boiler shop gang in 1899. Employees include: C.G. Fridinger, L.H. Urquhart (later a foreman), clerk Will Malone, J.H. Wigmore, M.G. Greenwood, Mickey Mack, Jim Wigmore, Walter Hudgins, Joe Hudgins, Ike Neff, Joe Neff, Oney Toohey, Otho Paul, Bill Lee, Pat Lillis, Pete Conway, and Tom Rose. The rest are unidentified. (NS.)

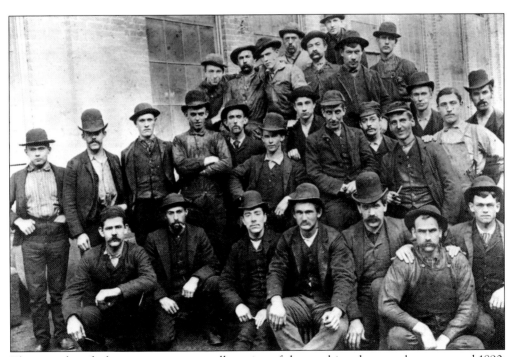

These unidentified men represent a small portion of the machine shop employees around 1890. Depending on the workload, RMW employed between 700 and 1,400 people during its early years and was the largest employer in the area. A majority of RMW's skilled workers came from the North, bringing their families and cultural attitudes with them. (VT.)

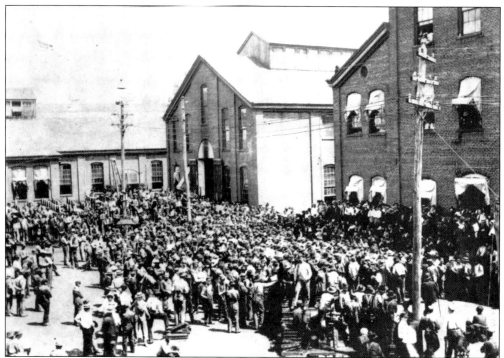

Roanoke Machine Works was incorporated into the Norfolk & Western Railway and renamed Roanoke Shops in 1897. Fredrick J. Kimball was first vice president of N&W when the facility was built, and it was under his leadership that the railroad thrived. Here, employees of Roanoke Shops gathered to show their respects on the news of his death in 1903. (NS.)

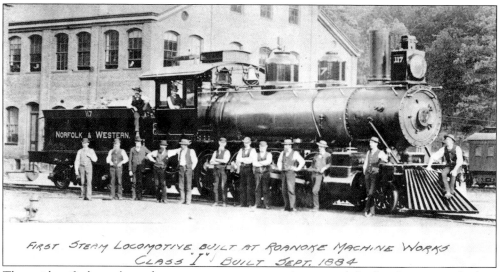

FIRST STEAM LOCOMOTIVE BUILT AT ROANOKE MACHINE WORKS
CLASS "I" BUILT SEPT. 1884

The unidentified members of management are seen posing around the first locomotive built at RMW. It is a 2-8-0 freight engine, also called a Consolidation. The 2-8-0 wheel arrangement was the most popular ever produced, with more than 25,000 examples of this type used by all railroads. (VT.)

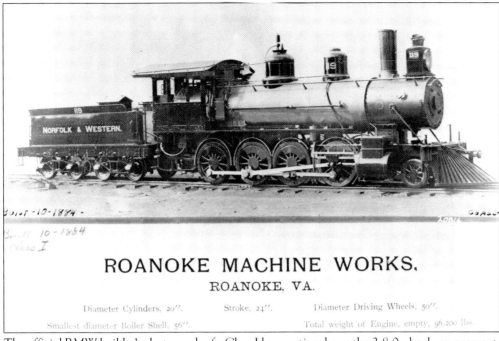

ROANOKE MACHINE WORKS,
ROANOKE, VA.

Diameter Cylinders, 20″. Stroke, 24″. Diameter Driving Wheels, 50″.

Smallest diameter Boiler Shell, 56″. Total weight of Engine, empty, 96,200 lbs.

The official RMW builder's photograph of a Class I locomotive shows the 2-8-0 wheel arrangement. There are two pilot wheels (those in front of the cylinder), eight drive wheels (those connected to the cylinder), and no trailing wheels (those behind the drive wheels). Using the wheel arrangement to describe a locomotive was more defining, since it was the same on all railroads, unlike class designations and nicknames. (NS.)

Shown later in its service life, locomotive 550 was originally numbered 118 and was the second locomotive built by RMW. Look closely, and one can see that the pilot wheels have been removed, making this later Class I, a 0-8-0 switch engine. Removal of the pilot wheels helped the locomotive maneuver through the tight curves and switches encountered in yard and shop tracks. (NS.)

17

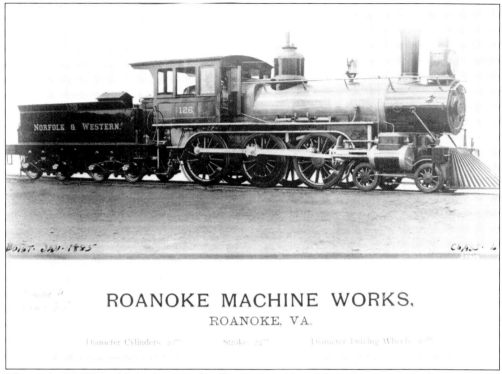

ROANOKE MACHINE WORKS,
ROANOKE, VA.

This is the RMW builder's photograph of locomotive No. 126, a Class L 4-6-0. The 10-wheeler provided better tractive effort and more speed than the traditional 4-4-0 American locomotives and was part of the trend of developing locomotives for specific tasks. Only three locomotives with this wheel arrangement were built at RMW. However, the railroad owned 56 others in classes C, D, and H. (NS.)

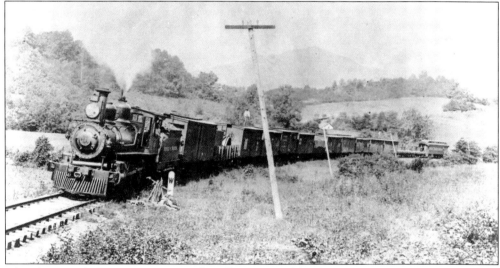

This photograph shows No. 126 at work, pulling a mixed freight and passenger train up a banked grade. Note the brakemen standing on top of the cars at the front and rear of the train. Originally, the 10-wheelers were the primary passenger and main line, light-freight engines, but the coming of newer classes relegated them to secondary power by 1910. All but two were retired by 1916. (NS.)

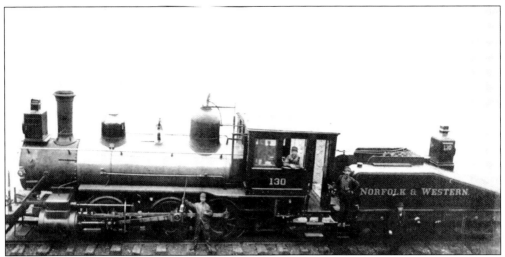

This photograph shows Class R switch engine No. 130 with her crew. The Class R's wheel arrangement was 0-6-0, making her well suited to yard work. It carried builder's No. 14 and was the second of six Class Rs built by RMW. Classes P and S also used the 0-6-0 wheel arrangement and all used the sloped, "swallow tail" tender. Most were sold or scrapped by 1915. (JG.)

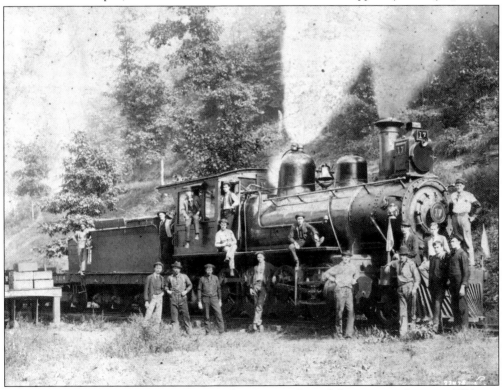

This photograph of locomotive No. 17, a Class F 2-8-0 Consolidation was taken near Elkhorn, West Virginia, in 1892. The locomotive was five years old. The Class F was retired by March 1916. The men around the engine include the crew, station agents, and clerks from Bluefield and Welch, West Virginia, and the Radford Division road foreman of engines (center, leaning on driver). (JG.)

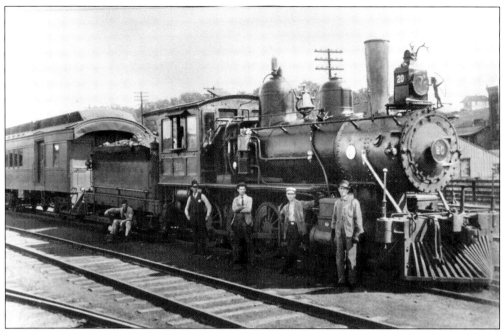

This Class F engine, No. 20, built in 1887 at the RMW, was scrapped in 1915. This photograph was taken when it was being used as a switcher in Radford Yard. The locomotive is coupled to a coach going to Walton, Virginia, where passengers transferred to main line trains. Crews were proud of their locomotives; note the Indian figure and antler decorations on the headlamp. (JG.)

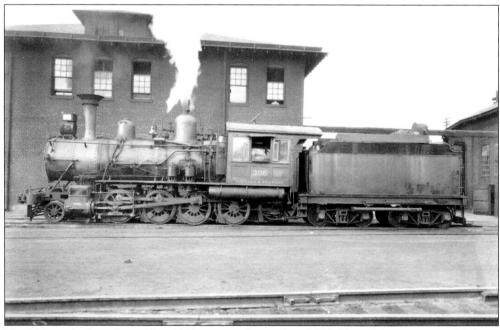

No. 306 was built in September 1892 as part of an order of 130 Class G locomotives. Of these, RMW built 81, including number 306. The preceding unit, No. 305, is on display in Saltville, Virginia, and is the only remaining example of the locomotives built by RMW prior to being absorbed by the Norfolk & Western Railway. (JG.)

20

Two

GROWTH OF
THE MAGIC CITY

In 1881, Big Lick was a sleepy, old time Virginia village with a population of about 400. By 1891, numerous publications were singing the praises of Roanoke, listing, among other things, its location, natural resources, industrious citizens, and rail access. The reported population was 25,000.

What was the cause of such amazing growth? To quote the *Roanoke Times*, "The young city immediately became the center of one of the most important railroad systems of the South. The Roanoke Machine Works, with a capital of $5,000,000, were immediately erected, and soon the easy-going village of Big Lick was transformed into the live, active, and progressive city of Roanoke."

Enoch W. Clarke & Company owned the Shenandoah Valley and the Norfolk & Western railroads as well as Roanoke Machine Works. To transform empty, agricultural land into a suitable industrial base of operation for a large railroad required considerable development. To complete such an immense project, Clarke & Company formed the Roanoke Land & Improvement Corporation (RLIC) as its real estate and development subsidiary. By the end of 1882, the corporation had purchased 1,152 acres of land and built the Hotel Roanoke, the Union Depot passenger station, and 128 workers' houses and had started construction of several large Queen Anne–style homes for high-ranking railroad officials. It had also completed 17,000 feet of streets and 4,000 feet of plank sidewalks and had straightened and deepened the channel of Lick Run Creek that ran through its land.

With the railroad and the development that accompanied it, other businesses and manufacturers soon moved into the area, including the Crozier Iron Company, the American Bridge and Iron Works, the Roanoke Rolling Mills, merchants, supply companies, banks, and druggists. The city seemed to spring from nowhere, which earned it the nickname "Magic City."

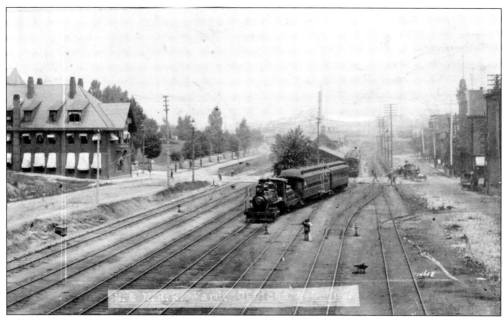

Hidden behind the train, in the center of the photograph, the Union Depot passenger station was one of the first buildings constructed by the Roanoke Land & Improvement Company. To the left can be seen the original Queen Anne–style N&W general office building, which burned in 1896. On the right is Railroad Avenue. There are no crossing gates or guards. Passengers walking to the station and pedestrians trying to go from Railroad Avenue to Shenandoah Avenue had to cross several sets of live tracks. Over the years, several people were killed or injured in the attempt. The photograph below was taken from the opposite side and shows some changes. Fences have been installed, and the original general office building has been replaced by the newer structure. (Both, VT.)

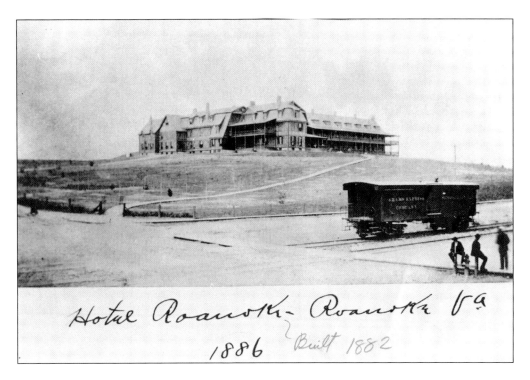

Hotel Roanoke- Roanoke Va 1886 Built 1882

The Hotel Roanoke was built in the very early growth period of Roanoke. This 1886 photograph is one of the few showing the original structure before the fire in 1896. George Pearson originally designed the Queen Anne–style hotel with 34 rooms, but before it was completed, the plain-looking annex on the right was added, doubling the capacity to 69 rooms. The fenced grounds included six acres lit by 20 gas lamps. A Philadelphia landscaping firm was hired to plant and arrange some 500 trees and shrubs. This photograph was taken before the grounds were complete, thus the gloomy and barren look. The lithograph, drawn at almost the same angle, looks a little more appealing. (Both, VT.)

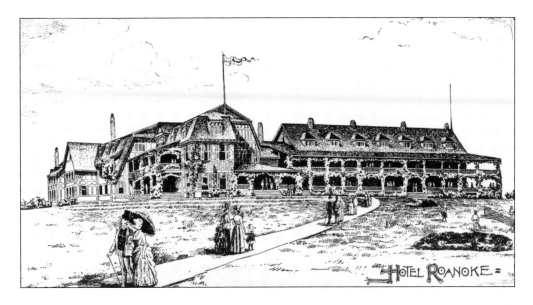

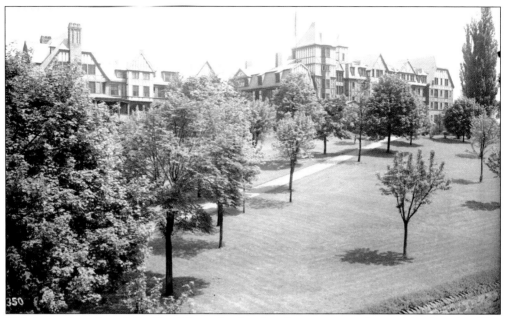

This is another view of the Hotel Roanoke showing the ornamentation and landscaping. The Queen Anne style, popular in the late 19th century, featured multiple gables and many pressed-brick chimneys. The hotel also featured some of the most modern conveniences, such as hot and cold running water and indoor toilets. However, there were no sewer systems, and the toilets emptied into a creek. (NS.)

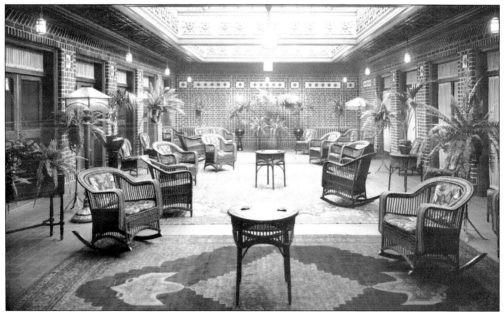

"One of the chief attractions of this hotel is its magnificent Sun Parlor with its glass front and luxuriant floral decorations," stated promotional literature of the time. Pictured here about 1910, public parts of the building were finished in hand-rubbed and polished English walnut, carved oak, cherry, and ash. Literature pointed out the elegance of the hotel's design and the beautiful views from its rooms. (NS.)

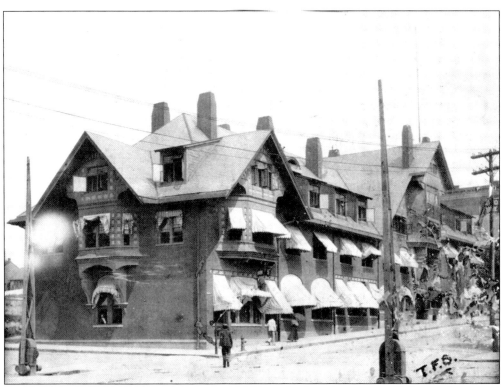

The original general office building for the N&W was built at the corner of Jefferson Street and Shenandoah Avenue. Built of pressed brick, and in the same Queen Anne style as the Union Depot and Hotel Roanoke, the structure housed the offices of both the SVRR and N&W railroads in 42 rooms on the upper floors. The ground floor was home to the Roanoke Land and Improvement Company as well as various retail establishments that had rented offices space. (Both, NS.)

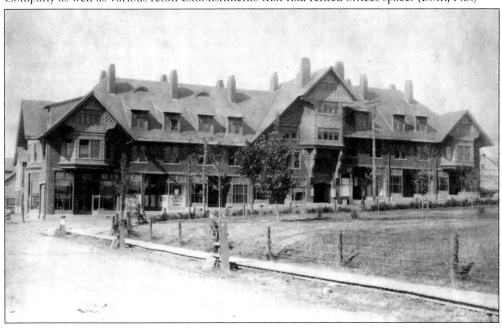

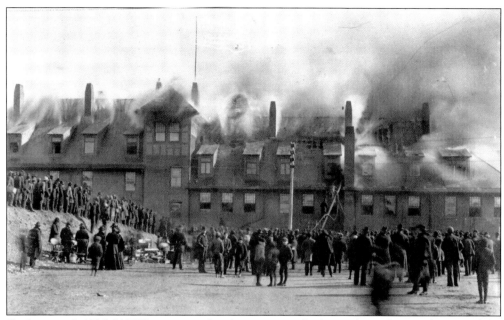

On January 4, 1896, N&W's corporate headquarters caught fire and was destroyed. Most of the company's early records and photographs were lost, resulting in a dearth of photographs from this early period. At the time of the fire, the country was in a deep depression, the railroad was in receivership, and there was fear that the reorganized company might relocate to another city. (VT.)

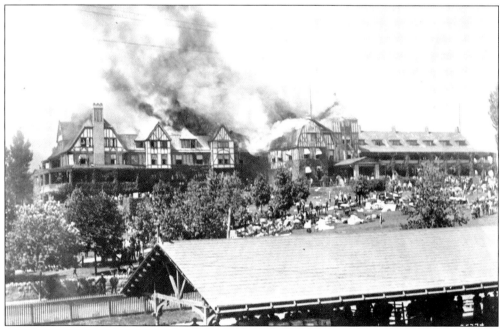

Another spectacular fire occurred on July 1, 1898. The Hotel Roanoke began to burn around 1:30 in the afternoon, and fire quickly spread through the structure. Employees from the RMW rushed over to try to save some of the furnishings. Some of the salvaged goods can be seen littering the hillside as the hotel burns. (NS.)

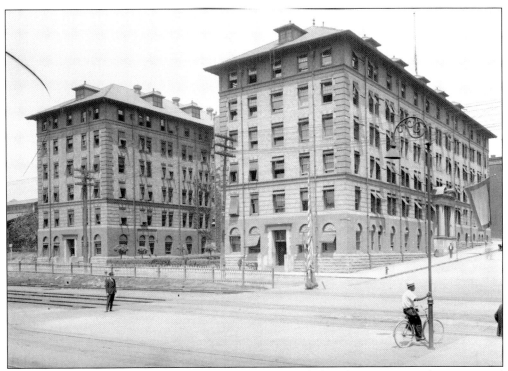

Fears of the N&W moving to another city proved unfounded, and construction of a new general office building began in 1897 on the site of the old complex. Within a decade, a second, almost identical building was added. This 1917 photograph shows both buildings. Today, they look almost exactly as they did then but now feature upscale apartments and condominiums. (NS.)

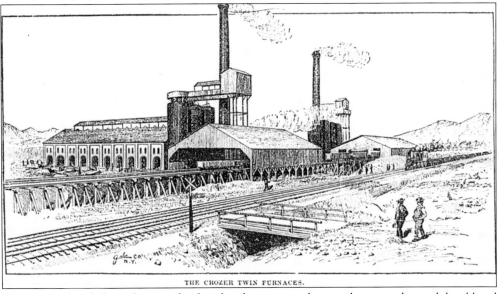

THE CROZIER TWIN FURNACES.

Once the railroad chose this area for their headquarters and major shop complex and shouldered much of the expense to develop the site, other industries soon followed. An early arrival was the Crozier Steel and Iron Company, built adjacent to the RMW. Once in blast, the company supplied the machine works with 10 tons of metal per day to build locomotives and cars. (RT.)

GENERAL VIEW OF BRIDGE, MACHINE SHOPS AND FOUNDRY OF AMERICAN BRIDGE AND IRON COMPANY, ROANOKE, VA.

The American Bridge and Iron Company was another large industry that moved into Roanoke. The company was reorganized as the Virginia Bridge and Iron Company in 1895 and employed about 600 people in its Roanoke plant. Aside from producing heavy railroad bridges and structural steel, the company began building cars for a variety of railroads. (RT.)

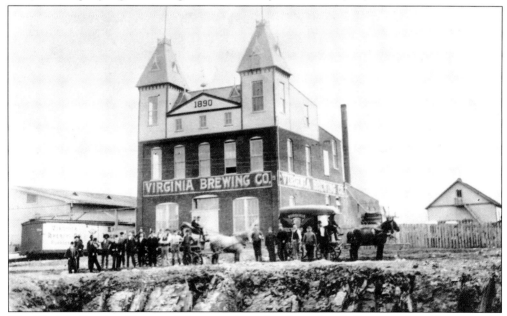

The Virginia Brewing Company's beer was introduced at a baseball game, played between the company's team and the Roanokes. Any player making it to third base received a free glass of the brew. The beer officially hit the market in August 1890 and sold its entire stock by 3:00 p.m. on the day it was introduced. The building pictured here burned in 1892, but the company thrived until 1916, when it was closed by Prohibition. (NS.)

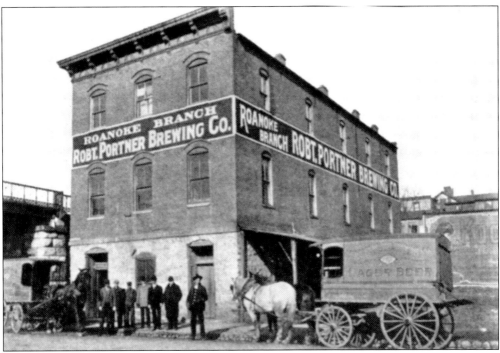

The Robert Portner Brewing Company was the largest brewer in the South. It had branches in a number of Southern cities, including Roanoke. Early Roanoke was a boomtown in every way, and, as the population grew, the number of saloons, distillers, and brewers grew also, along with the crime rate. The effect on the community was a regular subject for newspaper editorials and a concern for city government. (NS.)

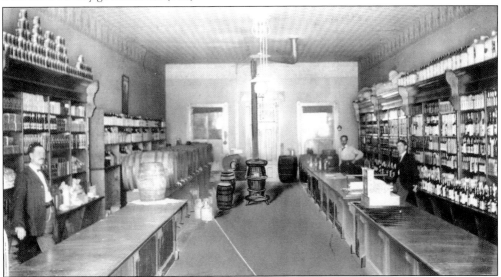

Before opening his liquor store in Roanoke, Burger B. Dillard owned the Opera House Saloon in Rocky Mount. Dillard's was located on Railroad Avenue. This area was referred to as "hell's half-acre" by the *Roanoke Times*. The *Times* stated in one issue, "This part of the city is becoming very obnoxious to all respectable citizens and a person carries his life in his hands who ventures there in the night time." (NS.)

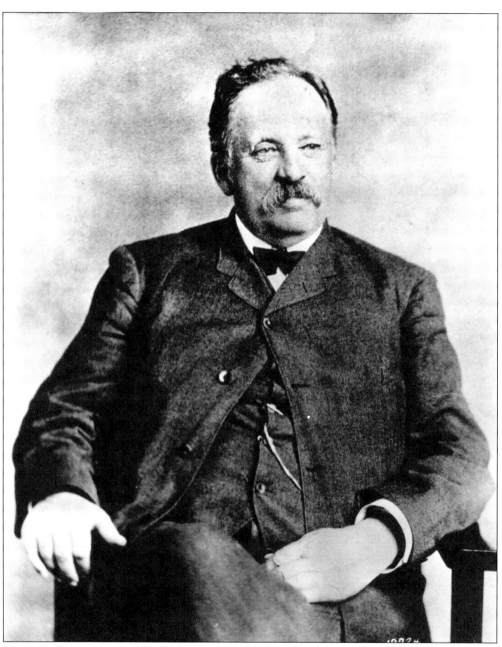

Henry S. Trout grew up in Big Lick. He was one of two local businessmen most responsible for bringing the railroad, and the accompanying growth, into the farming community that became Roanoke. As the city grew, he held many prominent positions in local and state governments, business, and banking. Surely, his most difficult job was that of mayor. Shortly after being elected came the depression of 1893. In September of that year, a black male was accused of attacking a white woman, and racial tensions, which were already high, exploded. A riot ensued, and the accused man was lynched. In an attempt to protect him, 8 citizens were killed and 31 wounded, including Mayor Trout, who was shot in the foot. (NS.)

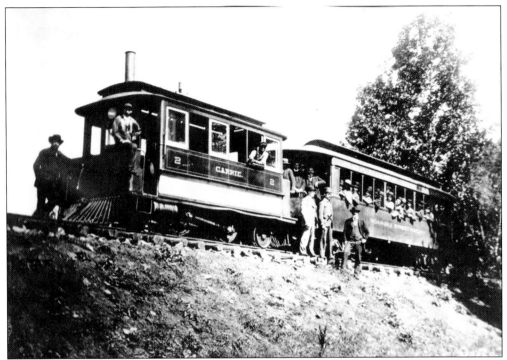

The "Carrie" was the first Roanoke Street Railway train to run between Roanoke and Salem. The man in the derby hat, standing between the cars, is Herbert J. Brown, editor of the *Roanoke Times*. The lynching in October 1893 was the second in 18 months, and the *Times* had been a supporter of extra legal justice. After the riot, Brown was arrested for inciting to riot. (NS.)

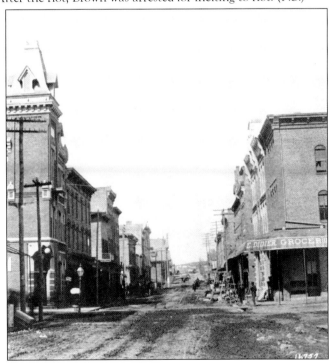

This is Jefferson Street and Campbell Avenue looking north about 1890. Note the unpaved, muddy streets; wooden sidewalks; and sparse streetlights. For the first decade of its existence, Roanoke suffered from infrastructure problems. To ease transportation woes, citizens formed the Roanoke Street Railway Company. One of its mule-drawn cars is in the center of the photograph. Didier's Grocery served as the company's office and ticket agent. (NS.)

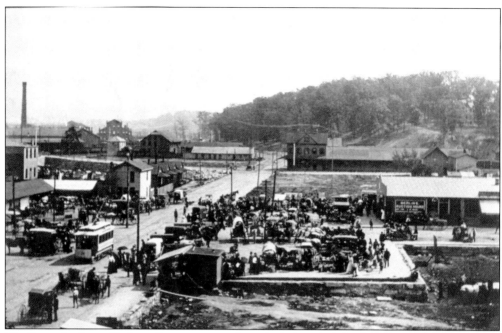

The Roanoke Street Railway Company was electrified after 1892. In this photograph, an electric car can be seen in the lower left on Campbell Avenue. Vendors fill the City Market, and in the background, the smokestack and buildings of Roanoke Shops can be seen. The building on the right, in the background, is the Roanoke Southern passenger station. (Historical Society of Western Virginia.)

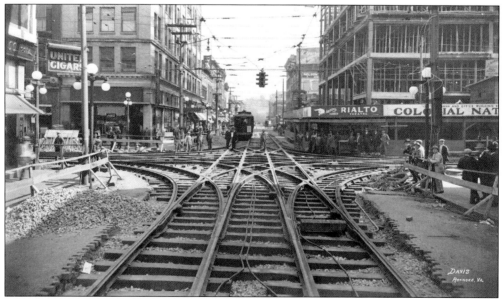

The Roanoke Railway and Electric Company's "Grand Union" intersection, located at Campbell Avenue and Jefferson Street, is under construction in 1926. Only 12 cities in the United States had such intersections, which allowed their streetcars to go straight, left, or right from any direction. Like most other cities, Roanoke's streetcars could not compete against automobiles and buses, and the line closed in 1946. (Virginia Room, Roanoke Public Libraries.)

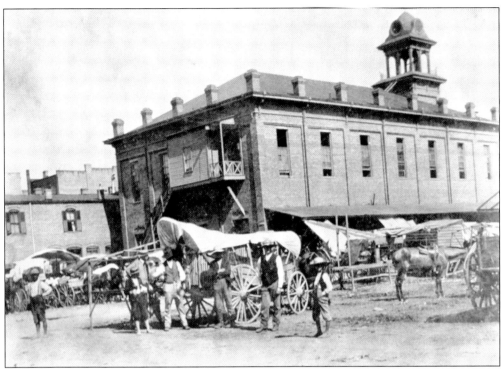

This photograph shows the City Market in 1889. Farmers often spent the night in their wagons, leaving their horses on the street. The smell of animal waste, mixed with spoiled meat and rotting produce, produced a stench that one person compared to a "glue or guano factory." The Roanoke Opera House was on the second floor of the market building and, in spite of its name, presented mainly vaudeville and burlesque acts. (NS.)

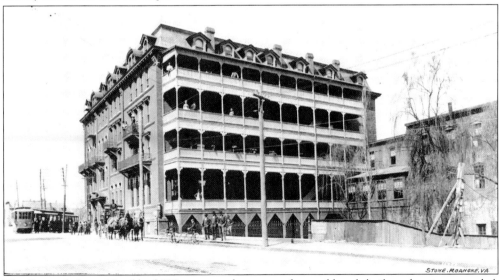

The Ponce de Leon Hotel had 120 rooms and was one of several hotels built as the city expanded. There was a fresh water spring bubbling up in the basement, which provided the basis for the hotel's name; it was referred to as the "Fountain of Youth" in hotel advertising. When built in 1890, the structure was the tallest in Roanoke and opened on Thanksgiving Day of that year. (NS.)

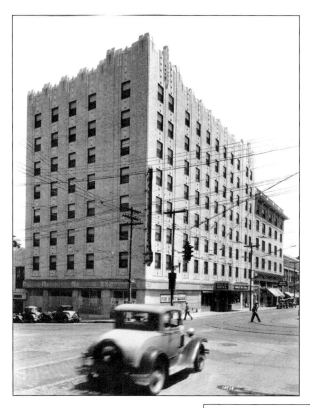

The Ponce de Leon Hotel is pictured in 1932. The original structure burned in December 1930 and was replaced with this eight-story, 183 room hotel in 1931. The hotel closed in 1970. The building was renamed the Crystal Tower and remodeled for offices. It still stands today and was recently purchased for conversion to a 70-unit apartment complex. (NS.)

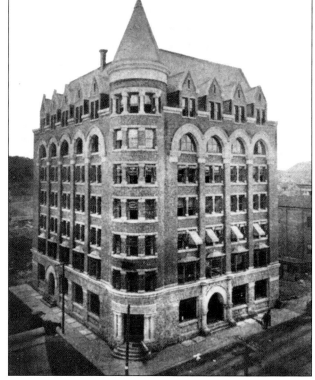

The Terry Building was constructed in 1892. It housed Peyton L. Terry's Roanoke Trust, Loan, and Safe Deposit Company. Terry speculated heavily in the land boom, and when it went bust in 1896, he lost his building, his bank, and his personal fortune. He died two years later; his building was demolished in the 1920s. (NS.)

Established in 1883, when this photograph was taken, the Bell Printing & Mfg. Co. was a branch office of a Lynchburg-based company. Pictured from left to right are Pryor Fitzgerald, F.R. Hurt, J.R. Thomas, H.O. Adams, and Joe Carper. The firm lost money for the first couple of years but began to prosper when Edward L. Stone was appointed branch manager in 1885. (NS.)

Under Edward L. Stone's management, the Bell Printing & Mfg. Co. continued to grow. In 1891, shortly before his retirement, J.P. Bell built this new three-story shop across from the Hotel Roanoke and next to the Norfolk & Western offices. Upon Bell's retirement, Stone partnered with his brother Albert and his brother-in-law Junius Fishburn; they bought the firm and renamed it the Stone Printing and Manufacturing Company. (VT.)

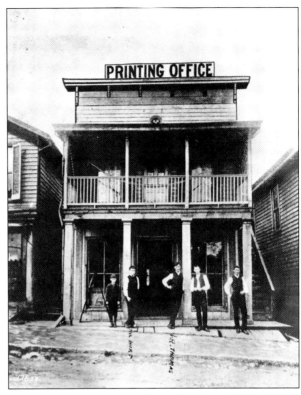

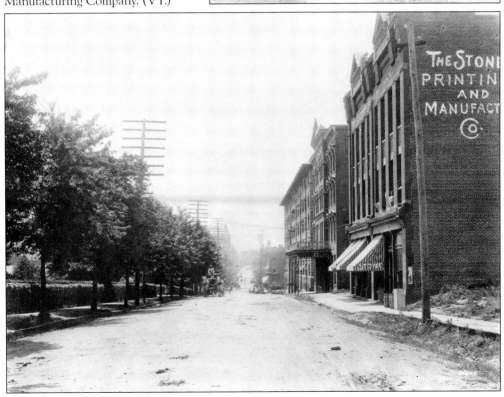

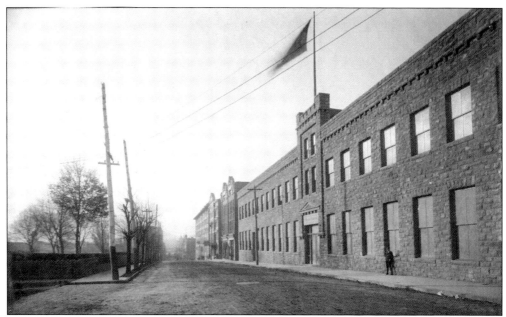

The Stone Printing and Manufacturing Company profits came mainly from N&W. But as the company's customer base expanded, it dominated the region and became one of the largest and best-equipped printers in the South. In 1905, Stone built a much larger building on the site of its former location; it is now home to the Social Security Administration. (VT.)

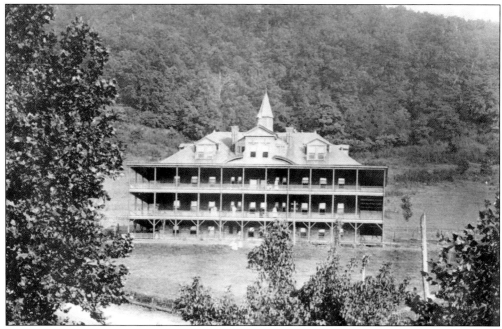

Deaths and injuries from industrial accidents grew with the city. This, plus concerns over disease control, led to the creation of the Roanoke Hospital Association, whose mission was to build a local hospital. RMW and Roanoke Land and Improvement Company donated land at the foot of Mill Mountain, but the depression of 1893 delayed completion until 1899. The hospital is shown here in 1904. (VT.)

In 1907, Dr. Hugh Henry Trout, son of Henry Trout, established a 40-bed facility that he named Jefferson Hospital. In 1914, the hospital established the Jefferson Hospital School of Nursing, the direct forerunner of today's Jefferson College of Health Sciences. The hospital grew to 151 beds by 1953 and by 1960 had trained 658 nurses, most of whom remained in the Roanoke Valley. (Virginia Room, Roanoke Public Libraries.)

In 1909, N&W's assistant surgeons, Dr. Joseph Newton Lewis and Dr. Sparrell Simmons Gale, opened a 26-bed "healing institution" at the corner of Third Street and Luck Avenue SW. The Lewis-Gale School of Nursing opened in 1911. Originally intended for their patients and for N&W employees, the hospital expanded to 66 beds in 1916 and to 166 in 1938. (Historical Society of Western Virginia.)

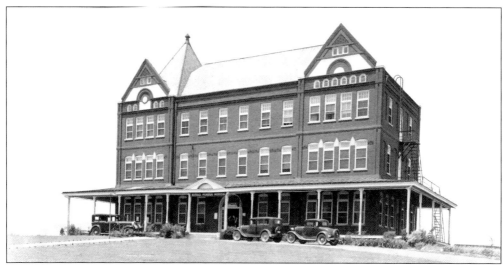

The Burrell Memorial Hospital opened in 1919, in a vacant building that had formerly housed a boy's school known as the Alleghany Institute. During the era of Jim Crow laws, the African American community could not get adequate health care in white hospitals, so Burrell Memorial was established to meet this need. Burrell was the first African American hospital to earn the full approval of the American Board of Surgeons. (NS.)

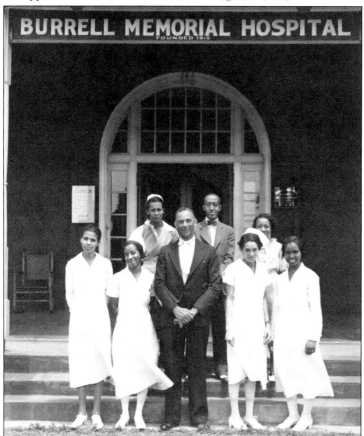

The man in the center of this photograph is Dr. James H. Roberts, vice president of the Burrell Memorial Hospital Association. Unfortunately, members of the Burrell Hospital staff are not identified. Dr. Roberts served his community in Roanoke for over 50 years and was a cofounder of the Magic City Medical Society. (NS.)

Three

SHOP GROWTH

Having built 152 locomotives, in 1897, RMW was absorbed into the newly reorganized N&W Railway and renamed Roanoke Shops of the Norfolk & Western Railway. At this time, management began to concentrate on the needs of their railroad. There was a growing demand for Pocahontas coal, and finding more efficient ways to meet that demand became the prime motivator for N&W. Between 1896 and 1920, N&W spent $192 million financing "multitudinous additions and improvements" to the system. Much of that money went into making improvements at Roanoke Shops. It had become clear that the shops were not large enough, nor were they equipped well enough, to produce the larger, more specialized locomotives needed to power the longer, heavier coal trains across the terrain serviced by N&W. During the years mentioned above, necessary improvements at Roanoke Shops resulted in a practical rebuilding of the shops involved in locomotive production. A new foundry was built. The old foundry was rebuilt and made suitable for boiler work, which had been housed in the erecting shop. The blacksmith shop was also rebuilt, as was the machine shop. Ancillary work, such as frogs, switches, and car wheels, which had been performed in the machine shop, was moved into buildings designed specifically for the tasks at hand.

Changes in tools and procedures were just as important but less obvious. The original belt-driven machine tools could make only small cuts compared to the newer high-speed machines that had become available. Improvements in boiler shop practices, as well as new tools, increased efficiency. With improvements in facilities and tooling, Roanoke Shops had the capacity to build any locomotive demanded of it.

This photograph is similar to the first photograph in chapter 1 but was probably taken a few years later, in the 1890s. A couple of smaller buildings and a second smokestack in the top left, very near the telegraph pole, were not visible in the photograph in chapter 1. The smokestack near the end of the machine shop was a part of the original powerhouse. (NS.)

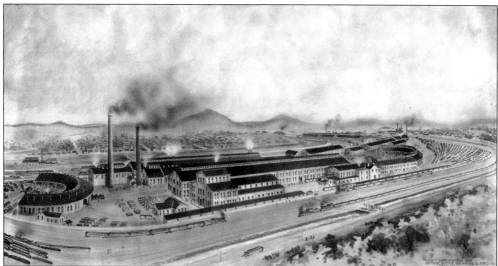

This early-1900s woodcut shows a clearer view of some of the changes taking place at the shops. The new powerhouse and second stack can be seen, and the new foundry, located at the rear of the complex, is in the background of this photograph. The original foundry, in the foreground at right, became the new boiler shop. (VT.)

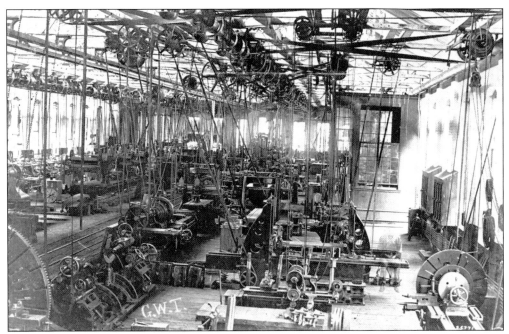

This photograph shows milling machines, lathes, and other equipment, all of which were powered by external shafting and belts. There were many problems with this arrangement. Power was lost through the belts and shafts, and the machines were relatively slow, which limited the cuts that could be made. Also, the exposed belts were very dangerous. (NS.)

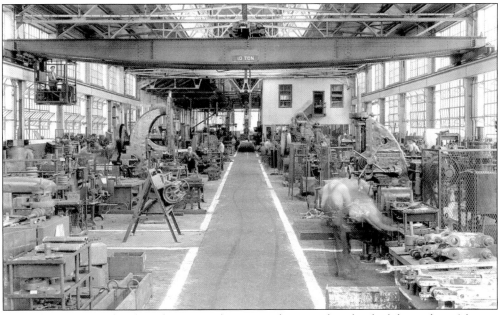

Around 1900, Roanoke Shops began purchasing machines with individual direct drive (electric motors). This type of machine gradually replaced older belt-driven machines. After 1906, all machines ordered had individual direct drive. These machines were able to make much larger cuts, making them faster and more efficient. They were also safer and eliminated clutter, the lack of which is clearly evident in this photograph. (JG.)

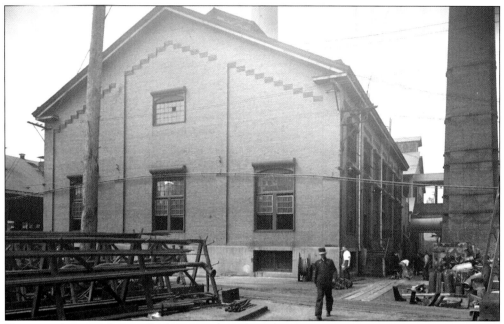

To power the new electrically driven tools and machines, a new powerhouse was needed. This 1917 photograph shows the building and the tall smokestack behind it. Built in 1902, it was originally equipped with three 200 horsepower boilers, furnishing steam for 395 kilowatts of electric generator capacity. This building recently collapsed when abandoned ash-handling facilities were torn down. (NS.)

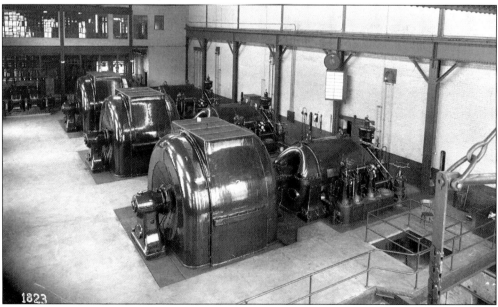

This photograph shows the interior of the powerhouse in 1917. Demands for both steam and electricity continued to rise. By the mid-1920s, steam capacity had grown from 600 boiler horsepower to 3,400, producing an average of 100,000 pounds of steam per hour. In 1926, this steam generated 4,878,288 kilowatt hours of electricity, serving both Roanoke Shops and the Hotel Roanoke. (NS.)

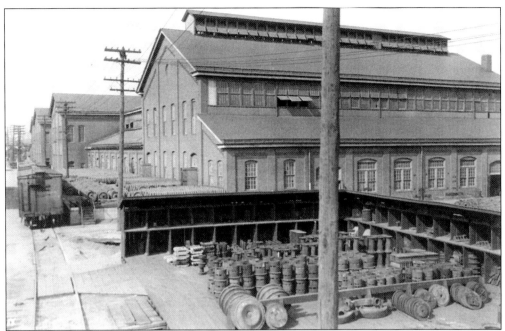

By the turn of the 20th century, handling boiler work in the erecting shop had become more difficult. In addition, castings were needed in greater numbers and variety than ever before. The solution was to build a new foundry at the east end of the property. The foundry was completed in 1909, and the old foundry given over to boiler work. (JG.)

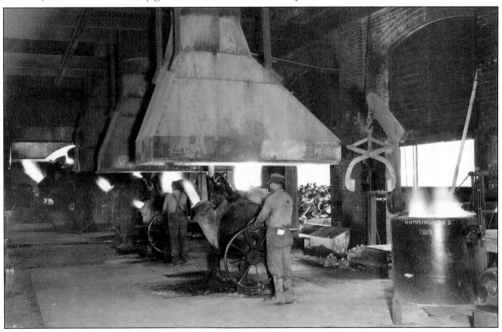

The new building provided ample room for foundry work. In this photograph, employees are heating brass in three furnaces. The brass would then be cast into the variety of accessories needed for steam locomotives. Apparently, there were regular inspections of equipment; the latest date, handwritten on the ventilators, is "3/21/37." (NS.)

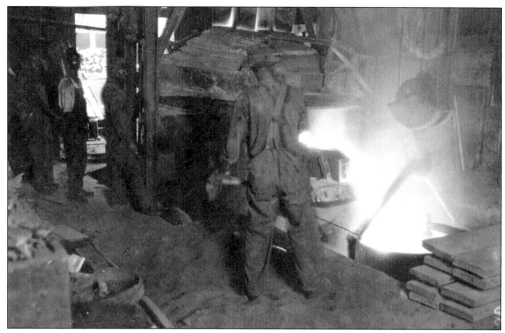

When the foundry was completed in 1909, it could not cast steel. Few railroad foundries had that capability. In 1918, this deficiency was corrected with the installation of a 3.5-ton electric melting furnace. In the photograph above, an employee is "tapping a heat," the term used for filling a ladle with molten steel. (NS.)

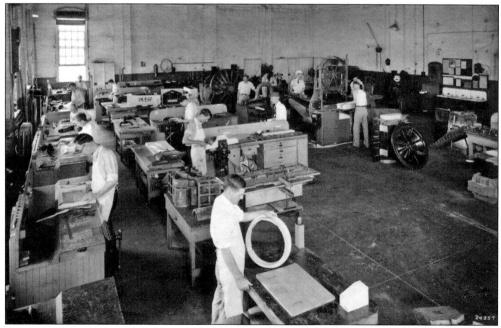

The pattern shop moved from the machine shop to the foundry when the building was completed in 1909. The men in this shop were skilled woodworkers. Their unique job was to produce the patterns needed for the many castings molded in the foundry. In this photograph, a large locomotive wheel can be seen in the background, and a pilot wheel is visible at center right. (NS.)

The pattern shop has been closed for many years, but thousands of patterns still exist. Many, like this wheel pattern, have been recovered for display at various locations. All these patterns were made of wood and had to be precisely built, backwards, so that when a mold was formed, a correctly oriented casting would result. (WM.)

The boiler shop moved into the old foundry building in 1909. In 1910, a riveting tower, measuring 92 feet by 72 feet by 38 feet, was added to the end of the building. However, the largest crane in the original building only had a 30-ton capacity, and the low roofline restricted the height of the loads. Heavier boilers continued to be built in the erecting shop, at left. (VT.)

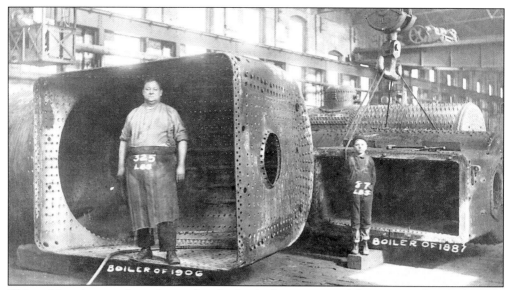

This striking photograph emphasizes how boilers had grown in size. The man standing in the 1906 boiler is Upton C. McDonald, described in *N&W Magazine*: "While not so light in avoirdupois, [he] embodied congeniality without limitation." Unfortunately, the child is unidentified. Note the low roofline of the original building and the wooden block floors, which replaced the dirt floor of the foundry. (JG.)

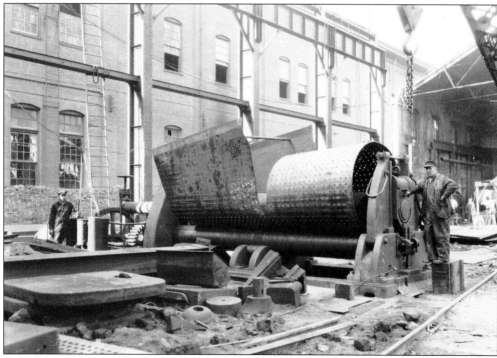

This photograph shows a firebox being rolled outside while the new boiler shop was being constructed. Inside the original building, in the background at right, the original crane runway is visible just above the employee's head. The new crane runway is seen at the top of the framework for the new construction. (NWHS.)

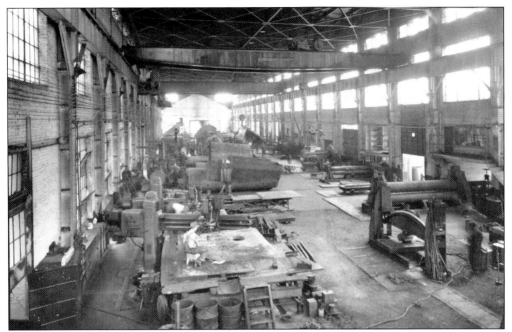

To address the problems caused by the low roofline, construction of a new building started in 1923. The end of the original building remained, and in this photograph, the original roofline can be determined by studying the far end of the structure. Raising the roof permitted the largest boilers to be lifted over each other and placed where needed. (VT.)

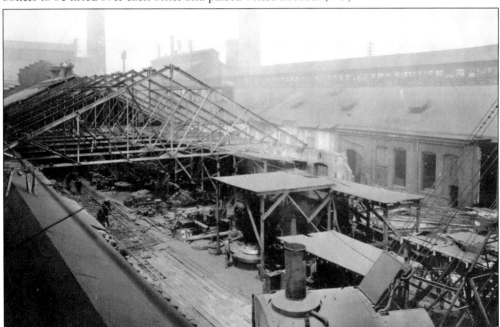

The original machine shop was a one-story brick building with metal roof trusses containing skylights. It measured 70 feet by 337 feet. This photograph shows work on a 200-foot extension, added to the east end of the building in 1901. Frog and switch work were moved out at that time. The blacksmith shop is seen in the background. (NS.)

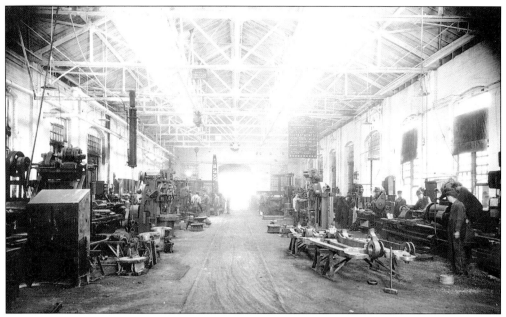

This photograph shows the inside of the original machine shop. There are only two light cranes visible, and the ceiling was too low for a bridge crane. Although not evident in this photograph, lighting was also a real problem. Each wall has a single row of incandescent bulbs with shades, one for each workstation. What appear as fluorescent ceiling lights are actually skylights—useless except on bright, sunny days. (JG.)

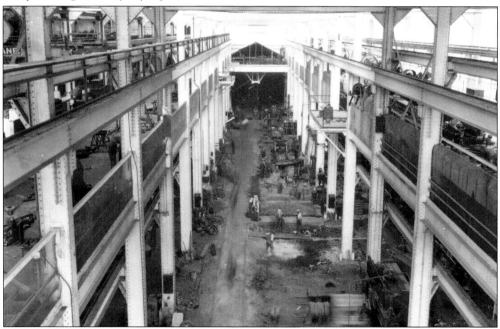

In 1924, an extension of 87 feet was added to the building. The roofline of the original building can be seen in the background of this photograph. Note how dark it appears under the original roofline, due to the poor lighting. The extension was wider than the original structure and much higher, allowing for good coverage with bridge cranes. (VT.)

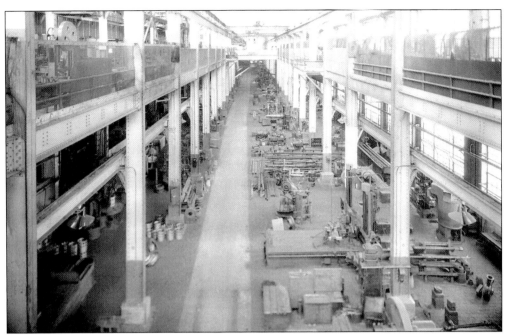

When the extension was completed, it was decided to remodel the entire building following the same pattern. Essentially, this meant constructing a new building over the top of the existing one. This allowed construction to continue while minimizing the disruption of locomotive repair work. The entire building was placed into service by December 1927. (JG.)

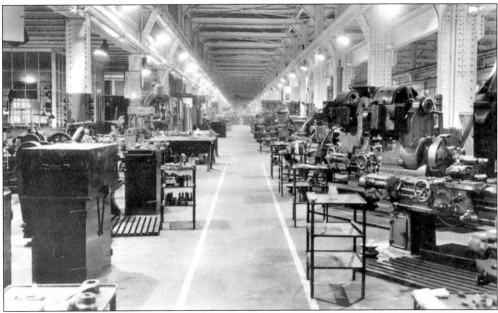

As can be seen from the previous photographs, the shop was completed with a main floor and three balconies. This photograph was taken on the second balcony, where the lighter machine work was done. The first and third balconies occupied much less area than this one and included locker rooms, offices, and the tin shop. Altogether, the shop now had 151,000 square feet of floor space. (JG.)

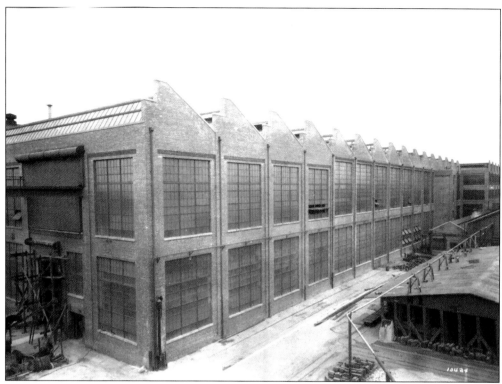

When the remodeling was finished, the building was 682 feet long by 123 feet wide. The large windows and the sawtooth design of the roof allowed for abundant light. Adequate electric lighting was also provided. The center section of the shop was covered by five 10-ton bridge cranes. The north and south bays were served by either two-ton or five-ton cranes. (VT.)

The first motive power offices were housed in this building as well as a general storehouse. The offices moved out when the motive power building was constructed in 1911. After that, the entire building was used as the general storehouse until the new general storehouse was constructed in 1948. The area occupied by this building is now the management parking lot. (VT.)

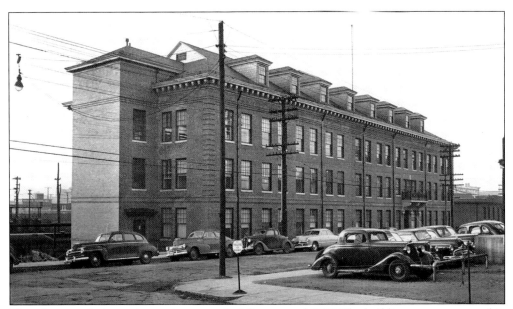

This photograph shows the motive power building around 1950. The building was constructed in 1911. The engineers who worked in this building were intimately familiar with steam locomotives. The locomotives they designed are considered among the most efficient ever built. In recognition of that, locomotive 611, housed at the Virginia Museum of Transportation, was named a National Historic Mechanical Engineering Landmark. (VT.)

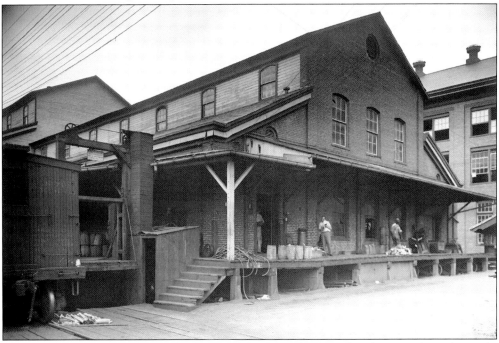

This is the rear of the original motive power building. It also served as the general storehouse for the shops. A new freight station was built in 1917 to handle additional material needed for the new shop at Shaffer's Crossing. This building continued to serve as the storehouse for Roanoke Shops until torn down in the late 1940s. (NS.)

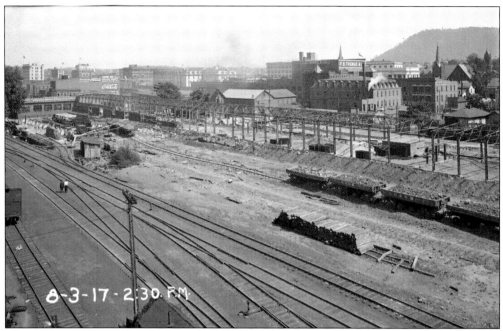

Plans to expand the yard and build a new facility at the west end of Roanoke (Shaffer's Crossing), meant a larger, more centralized freight station was needed. This photograph shows the new construction. The station was about midway between Roanoke Shops and Shaffer's Crossing, on the opposite side of the tracks from the general office building. (NS.)

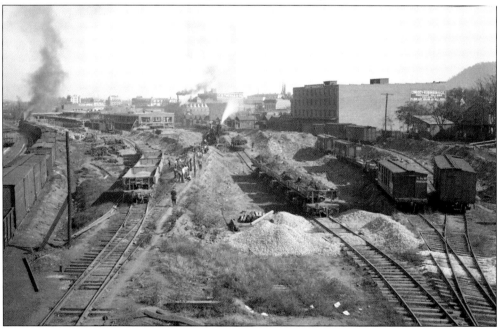

This photograph was probably taken from the Fifth Street overpass. Construction is further along than in the previous photograph, with many of the walls up and awnings in place. Steam shovels are filling dumper cars with dirt to be hauled away from the site. By the end of 1917, the freight station was complete, and Shaffer's Crossing was finished by 1919. (NS.)

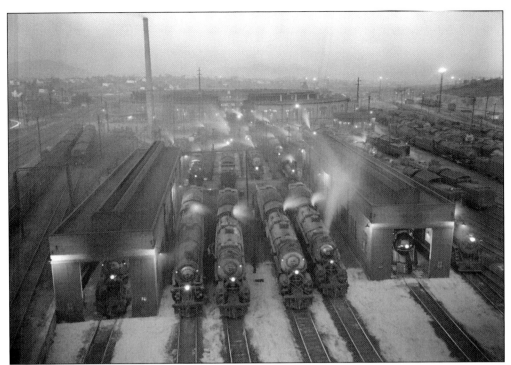

This spectacular evening photograph of Shaffer's Crossing was taken in 1943. The "long houses" at the left and right were for lubrication and minor repairs. This routine servicing could be accomplished in minutes, rather than hours, and locomotives seldom had to enter the roundhouse (visible in the background) except for periodic inspection and heavier repairs. (NS.)

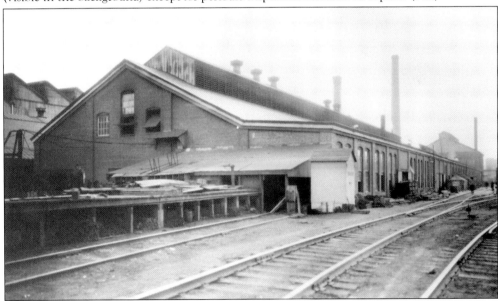

This image of the blacksmith shop was taken shortly before it was rebuilt in 1930. The building had been expanded several times since its original construction but was still considered inadequate. Moreover, the construction of the building made it impossible to install more modern facilities. In February 1930, a total of $225,000 was appropriated to build a new smith shop. (JG.)

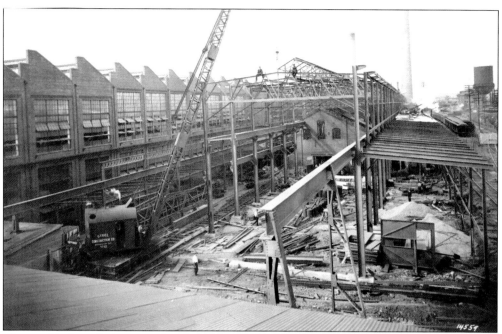

The new blacksmith shop is under construction. This was the last of the original shop buildings to be rebuilt and, like the others, was designed to be constructed around the existing structure. The recently completed machine shop is seen at the left in the photograph, and the old blacksmith shop is visible inside the framework of the new building. (NS.)

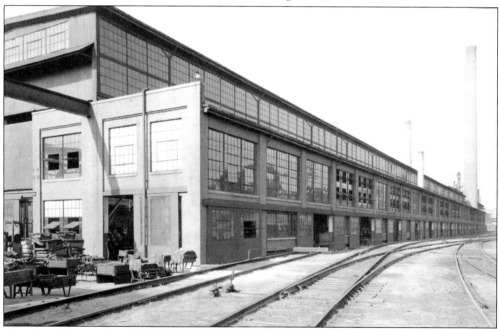

When completed, the new blacksmith shop was 665 feet long and 100 feet wide. The center bay was 41 feet high and was equipped with a 20-ton bridge crane. The runway for this crane extended 60 feet outside the building. The north and south bays were both 25 feet by 25 feet. The new building had twice the volume and 10 times the glass area of the old shop. (NS.)

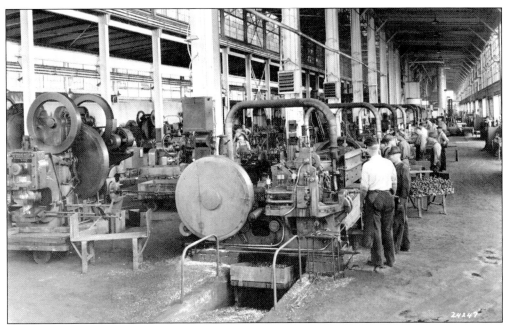

The volume inside the new blacksmith shop can be judged from this 1937 photograph. In addition to the 20-ton crane in the center bay, the south bay, at left, was equipped with a 10-ton bridge crane, with a runway that extended 232 feet beyond the building. Blacksmiths manufactured bolts, handgrips, steps, and most any other small parts that might be needed. (NS.)

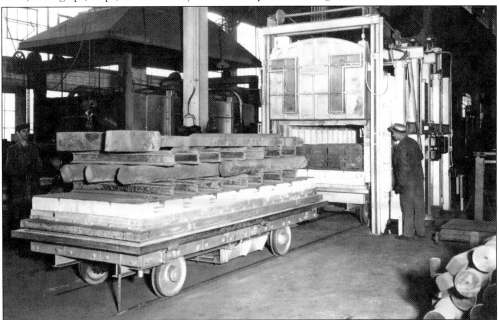

The north bay of the blacksmith shop contained the large furnaces. They were ventilated through the roof, which prevented installation of an overhead crane. This photograph shows two main rods being placed into an electric annealing furnace. Electric furnaces, such as this, and installation of a new fuel oil circulating system, for older furnaces, greatly reduced smoke and gases in the shop. (NS.)

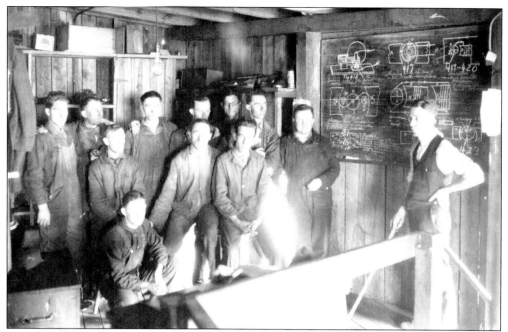

Not all shop improvements were to equipment and structures. This 1923 photograph shows "R. L. Peck's Noon-Hour School in Electricity." Peck, at right, was the gang leader in the Locomotive Lighting Department. To attend, employees voluntarily gave up 40 minutes of their one-hour lunch break and even had to buy their own books. But like most Roanoke Shops employees, they wanted to excel at their work. (NS.)

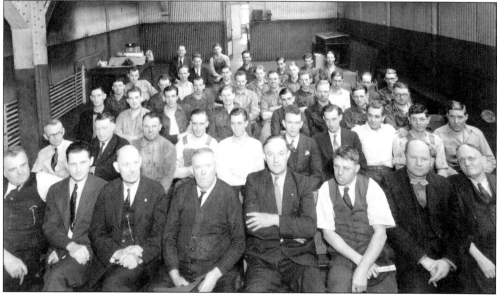

Math classes were held at the shops during the mid-1930s. There were beginner and advanced classes, which met three times weekly over an eight-month period. The classes stressed practical shop arithmetic, algebra, geometry, and trigonometry. These graduates, like the employees in the electrical class shown previously, had to volunteer their time and bear the expense of their books. (NS.)

Four

LOCOMOTIVE PRODUCTION

The Roanoke Machine Works (later Roanoke Shops) gave N&W a capability possessed by few other railroads, the ability to design and build their own steam locomotives in their own shops. This meant their designers could easily experiment with a variety of potential changes and determine the most efficient use of their motive power. Roanoke Shops ability to take the designers' ideas and turn them into wheels on the rails resulted in what many consider the finest steam locomotives ever built. Tests run by N&W proved their steam locomotives could compete economically with the early diesels, and, as a result, Norfolk & Western was the last major railroad in America to convert to diesel.

Building a steam locomotive required coordinated efforts by several different crafts, spread out among many different shops. The storehouse had to procure raw materials, plus any parts not made in house. The foundry made castings for all but the largest components, which were then machined in the machine shop. Boilermakers formed the boilers from raw sheets of steel in the boiler shop, while blacksmiths forged the driving rods and other components in the smith shop. Pipe fitters ran the extensive piping required, and machinists assembled the whole in the erecting shop. It was a unique skill set, highly regarded by management.

In this chapter, there are photographs of many steam locomotives. These were classified by their wheel arrangement, such as 2-8-0. This means there are two pilot wheels at the front, eight driving wheels (four on each side), and no trailing wheels under the cab. Also, most were given nicknames; a 2-8-0 was known as a Consolidation. Most railroads gave them a class designation as well, such as Class A. Of these methods of classification, only the wheel arrangement was standard across all railroads.

From 1884 to 1953, Roanoke Shops produced a total of 447 steam locomotives, and from 1930 to 1953, it provided all but 30 of the locomotives required by Norfolk & Western. Among these were Classes A, J, and Y—the "Magnificent Three."

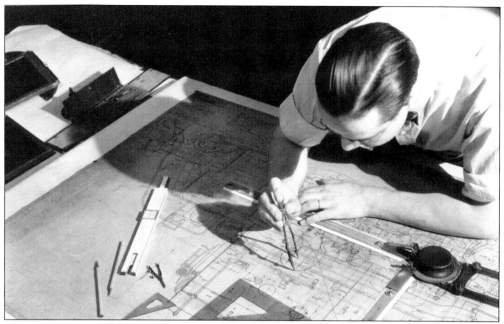

Demonstrating a skill lost in today's world of computer-aided design and manufacture, the N&W engineers drafted designs by hand, which resulted in the finest locomotives of their type ever built. These locomotives continued to prove their worth right to the end, and the Class J was named a Historic Mechanical Engineering Landmark in 1984. (NS.)

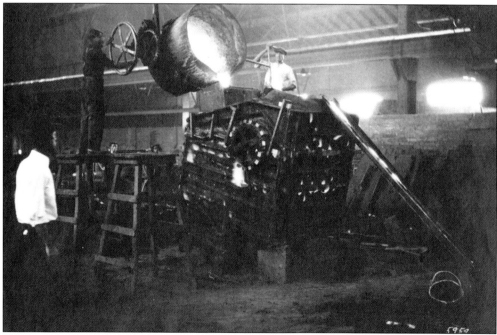

While some parts such as air pumps, super heaters, lubricators, and lights were bought from commercial suppliers, most components were made in Roanoke Shops. The foundry could cast all but the largest pieces, such as the single-piece frame, and any finishing work could be done in the other shops. These men are casting a locomotive cylinder about 1910. (NS.)

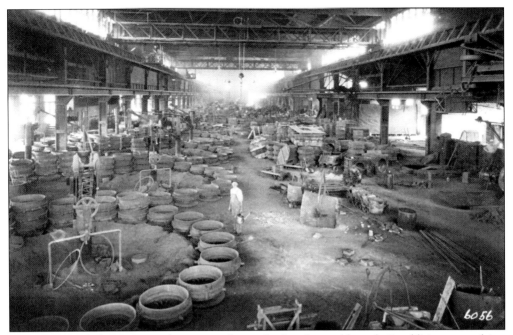

This photograph demonstrates the variety of parts the foundry could supply. In addition to supplying locomotive and car parts, they cast needed parts for the whole system, such as material for bridge construction and track maintenance and iron for the coal pier at Lambert's Point. (NS.)

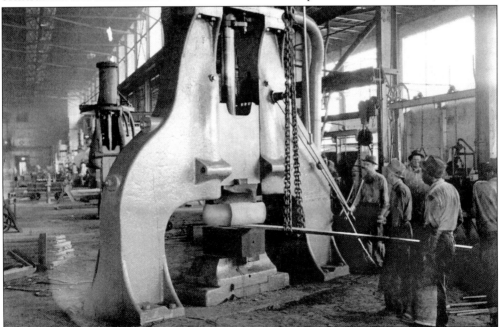

It took about two days to forge a main rod in the smith shop. First a carbon vanadium steel billet, seen in the steam hammer, was heated to 2,100 degrees Fahrenheit. While the billet was heated, the hammersmith and his crew of five would make preparations at the steam hammer. Crewmembers had different responsibilities and all answered to the hammersmith, who was responsible for the forging. (JG.)

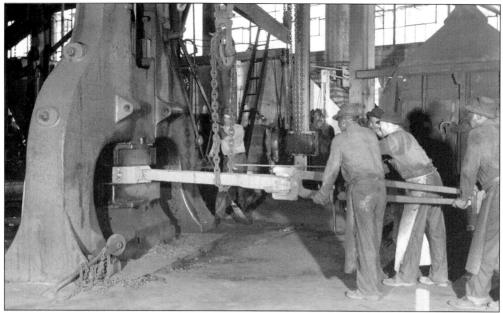

On the second day, the forging process began and had to be completed in one day. Done in three stages, with reheating in between, the center of the rod was formed first, then the two ends. When finished, the original billet, which weighed 3,200 pounds and measured 11 by 20 by 52 inches, was transformed into a main rod weighing 3,075 pounds and measuring 10 feet, 11 3/4 inches. (NWHS.)

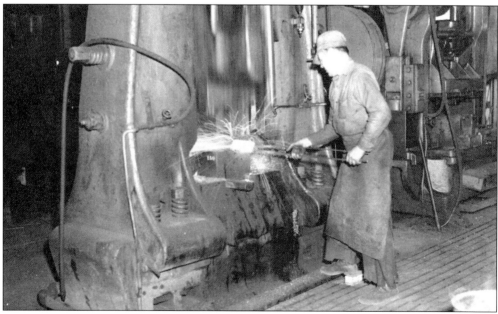

In this photograph, a blacksmith is forging a part with the steam hammer. When this photograph was taken in the 1940s, steam hammers had existed less than 100 years and would soon be superseded by hydraulic or mechanical presses. They could deliver a blow of many tons, but the force could be varied so precisely that a skilled hammersmith could strike a pocket watch without breaking the crystal. (NS.)

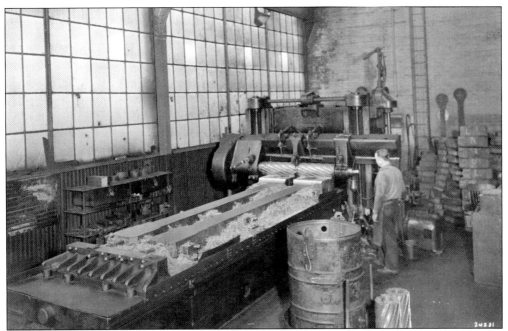

After forging, the rods were heat treated, then placed on a horizontal milling machine for finishing. Two rods could be cut at once. They were then drilled and sent to a vertical milling machine, where the ends of the rods were finished. After other drilling and fitting operations, they were sent back to the horizontal milling machine for final trimming. (NS.)

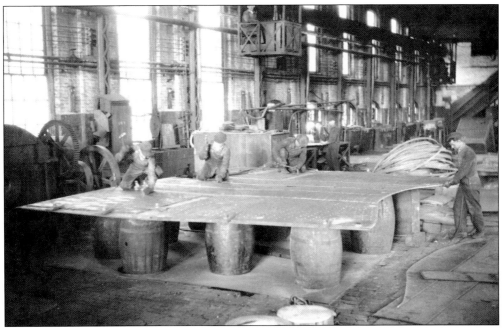

In the boiler shop, boilermakers have begun construction by clamping a template to the boiler sheet, using it to lay out holes for the stay-bolts. In the background, the sheet is being cut with a torch, and on the right, it is trimmed with a pneumatic hammer. Like tailors, boilermakers cut pieces to a precise pattern and stitched them together, using steel rivets instead of thread. (NS.)

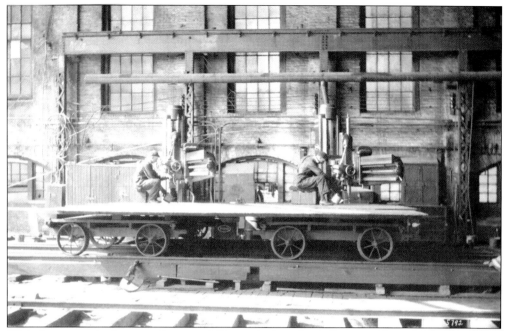

With the pattern laid out, six sheets could be stacked on the drill press table and the holes drilled in one operation with a radial drill press. On a large boiler, more than 4,000 holes had to be punched and drilled before the sheet was rolled. The work was so precise, all holes were expected to line up between the inner and outer sheets. (NS.)

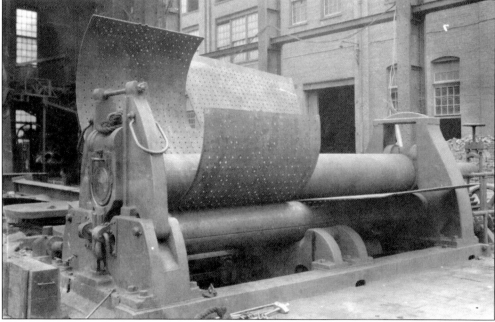

With the layout and drilling complete, the sheets were put in a large rolling mill and rolled into the round shape needed for a boiler. These machines could roll sheets up to 1.5 inches thick. The vertical adjustment of the two ends on the upper roller was independently controlled, which allowed forming either conical or circular sheets. (NS.)

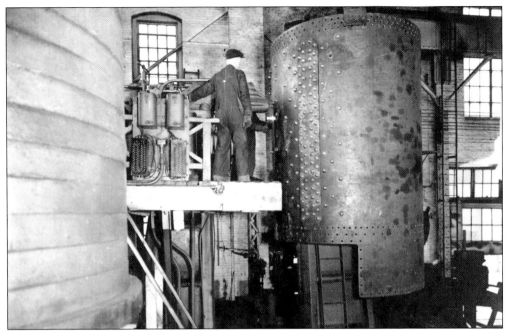

Once the sections were complete, they had to be riveted together. One end of the boiler shop contained a riveting tower. This was so the sections could be stacked and riveted vertically; the sections were so heavy that if they had been assembled horizontally, they would have warped. (NS.)

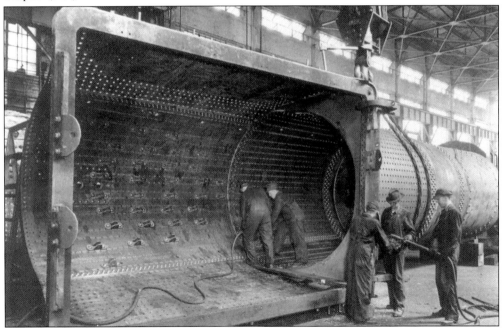

With the boiler sheets riveted together and connected to the upper firebox, the boilermakers inside the boiler are riveting the side sheets, while those outside appear to be making adjustments to their pneumatic riveter. The most striking thing may be the sheer size of the boiler, which appears to be about nine feet in diameter. This boiler is for Class A locomotive 1207 or 1208. (JG.)

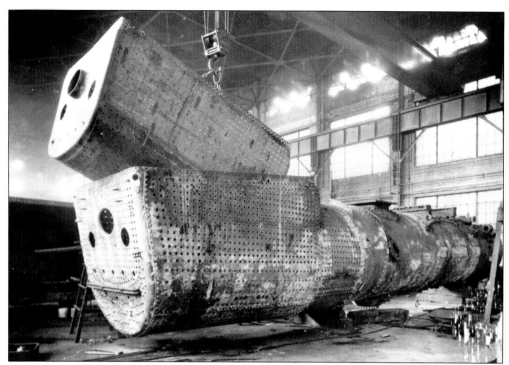

In this photograph, the inner firebox shell is being inserted into the outer shell. The two sections were held together by 4,000-plus stay-bolts, the holes for which, as mentioned earlier, were drilled before bending the sheets. Stress due to uneven expansion between the inner and outer firebox shells would sometimes break the bolts, so they were regularly tested and repaired. (NWHS.)

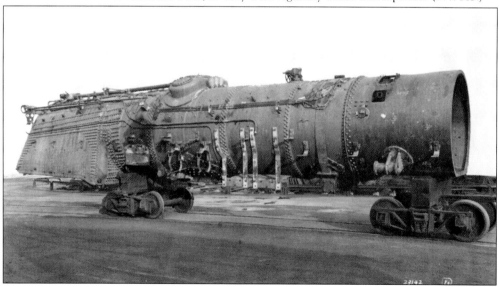

With the boiler complete and some of the piping in place, the boiler is placed on trucks for transport to the erecting shop. Besides being several times larger than older boilers, construction methods had improved over the years; this boiler featured forged braces, many welded seams, and all rivets were applied with power-driven hammers. A completed Class Y6 boiler, pictured, weighed 120,000 pounds. (NS.)

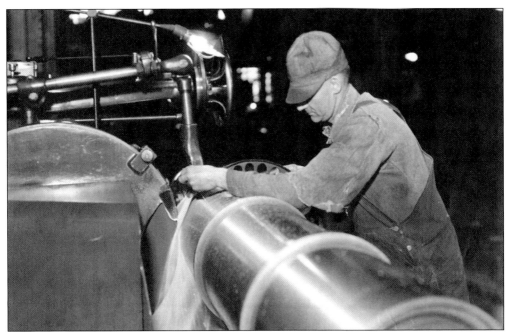

In this photograph, a machinist is grinding an axle sleeve to correct tolerance. The grinder had an 18-inch wheel with 96 inches of travel. The sleeve was cast in the foundry, and the inner race of the tapered roller bearings was pressed onto it. The sleeve supported the weight and stress of the locomotive while the axle merely connected the two wheels. (NS.)

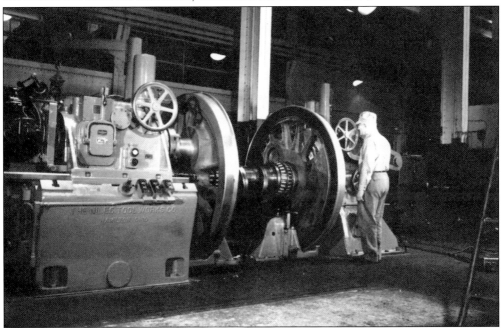

Prior to 1855, wheels were hammered onto axles. Getting them set correctly was a hit-or-miss affair. Crank pins had to be set 90 degrees apart, and if the angle was off, the pistons would not work together properly; in extreme cases, the locomotive might not even be able to move. The quartering machine seen here was designed to bore both pins at once at the correct angle. (NS.)

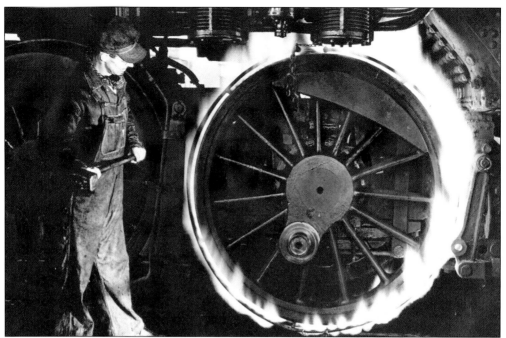

Unlike modern locomotives, steam engine wheels had steel tires applied to them, which would be replaced when necessary. To apply the tire, a ring with outlets around its circumference was placed on it. Gas filled the ring, then was lit, heating the tire until it swelled enough to slip over the wheel. As the tire cooled, it shrank into place to fit the wheel. (NS.)

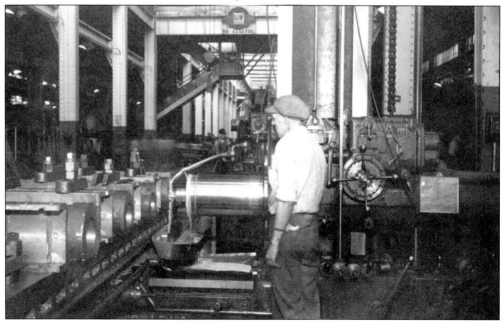

A machinist is using a horizontal boring machine to hone a locomotive cylinder. Many locomotives used cylinders that were cast separately from the frame so they could be machined individually. After boring, a replaceable liner was inserted. The cylinders tended to wear at the bottom. When wore too badly, the liner could be replaced without changing the cylinder. (NS.)

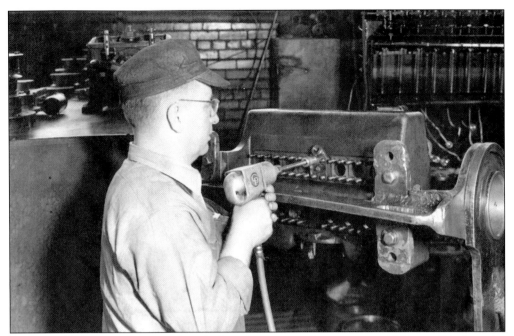

In this 1947 photograph, an unidentified machinist is working on a manifold, possibly from the throttle assembly, in the air room. Aside from air brakes and related items, employees in the air room worked on various locomotive appliances, such as whistles, bells, lubricators, boiler check valves, safety valves, and air pumps. (NS.)

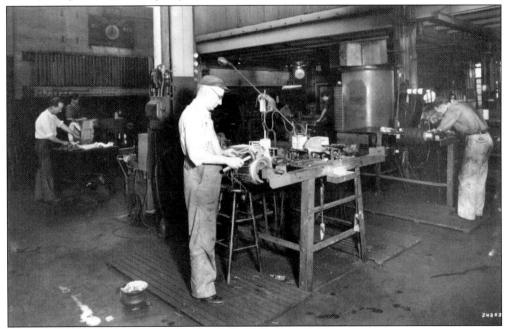

In the electrical shop, employees appear to be working on a generator armature. A steam engine did not require much electricity, but power was required for headlights and cab signals. This power came from a generator located near the cab; it was turned by a small steam turbine, which supplied 32 volts DC (direct current). (NS.)

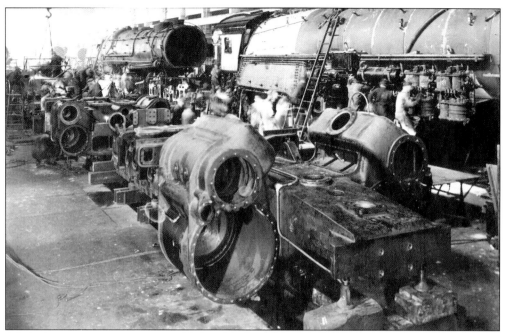

All the locomotive parts were assembled in the erecting shop. The front and rear frames were among the few parts not manufactured at Roanoke Shops. These were very large castings, totaling well over 100,000 pounds, including the cylinders, frame, and connection castings. This eliminated many separate castings, reduced construction time, and made the whole locomotive stronger. (JG.)

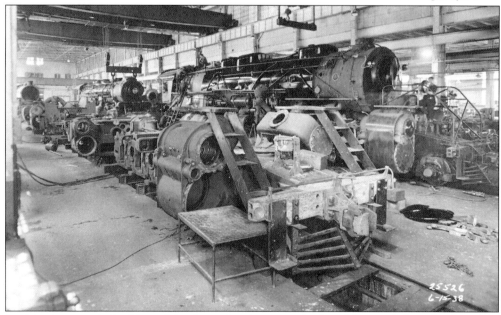

In this photograph, buildup of the frame has begun with the addition of the pilot, knuckle, front steps, and platforms. The cylinders and pistons drove the locomotive. The smaller cylinder contained a valve that permitted steam, then exhaust, to enter. The larger cylinder contained the piston and drive rod assembly. An articulated locomotive had one boiler supplying steam to the front and rear engines. (VT.)

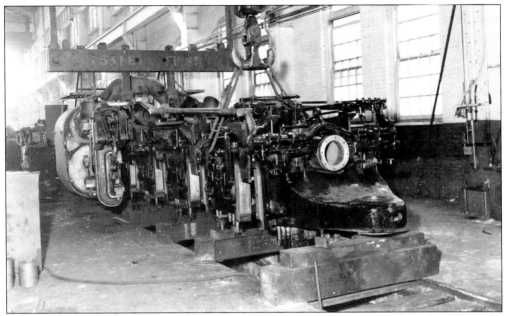

The frame is complete now and ready for wheeling. This is the rear view of the front frame for a Y6 locomotive. Nearest the viewer is the articulating pivot, which allows the front engine to turn out of the centerline of the boiler. Without this ability, these very long locomotives would not have been able to negotiate the curves on most tracks. (NS.)

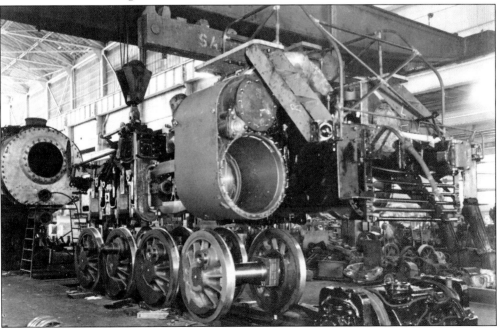

Its buildup completed, the front engine frame is lowered onto its wheels. Positioning the wheels was important because the pedestals in the frame had to engage the roller bearings on the axles, and the clearance was only about .012 inches. Since the rods are of precise length and the various parts of the valve gear have to be located properly, this type of precision is necessary throughout the frame. (NS.)

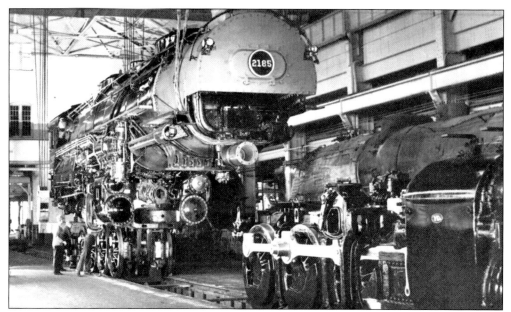

Both engine frames are now complete. The rear frame, with its cylinders and valves mounted on the boiler, is being lowered onto the rear wheels. A Class Y was a compound articulated locomotive, meaning the steam was used twice. First, it powered the rear high-pressure cylinders, then the front low-pressure cylinders (compound). The front engine frame turned independently of the boiler and rear engine frame (articulating). (NS.)

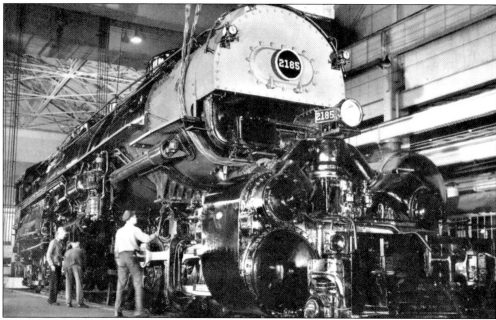

This photograph shows the final part of the wheeling process, where the entire locomotive is lowered onto the front engine frame. This photograph also illustrates the difference in size between the much larger front low-pressure cylinders, compared to the rear high-pressure cylinders. The compound articulated locomotive was often referred to as a "Mallet," after the Swiss designer Anatole Mallet. (JG.)

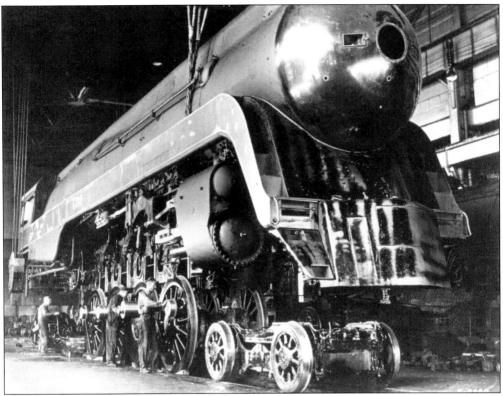

The wheeling process for non-articulating locomotives was similar. The engine frame was mounted to the boiler and the whole lowered onto the prepositioned wheels. Two cranes were used, and the employee at the rear acts as the coordinator for both crane operators. (NS.)

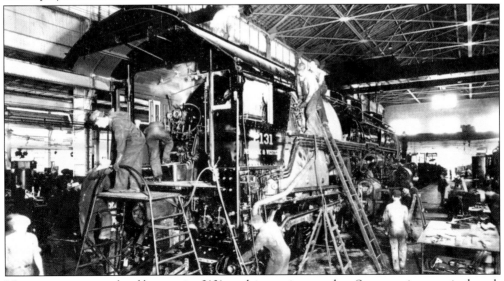

Men swarm over completed locomotive 2131, applying various touches. Steam engines required much more maintenance than diesels, illustrated here. In this photograph, 12 men (visible) work on this engine, and there probably are at least six more on the other side. In Roanoke Shops today, seldom would there be more than four men assigned at one time to work on a modern diesel. (JG.)

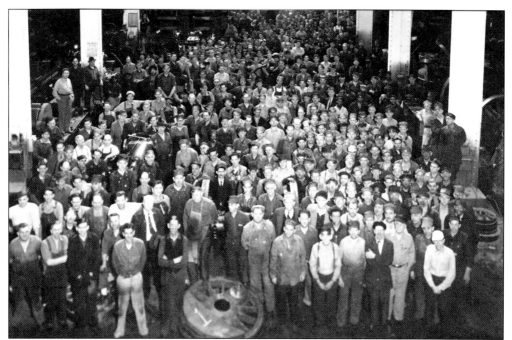

Taken in the mid-1940s, this image shows approximately 500 men from various shops that have gathered in the bay of the machine shop for a group photograph. These men possessed the necessary skills to convert blueprints into locomotives. These skills were prized by management, who sometimes kept the men working during hard times rather than laying them off and risking losing them to other industries. (NS.)

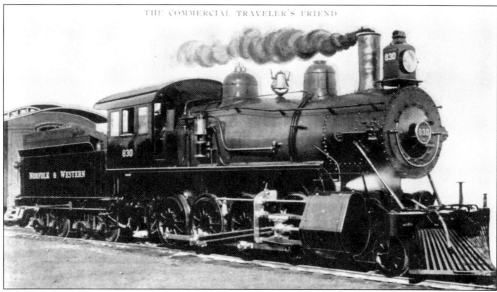

The new Roanoke Shops began producing its first locomotives in 1899, with 16 Class W1 2-8-0 Consolidations. Previously, 30 Class W locomotives had been ordered from Baldwin in 1898 and 1899. The W1s utilized piston valves instead of the slide valves used on the Baldwins. Eventually, all the Baldwins were converted and reclassified as W1s. This may be N&W's first experiment with a design change to improve locomotive efficiency. (VT.)

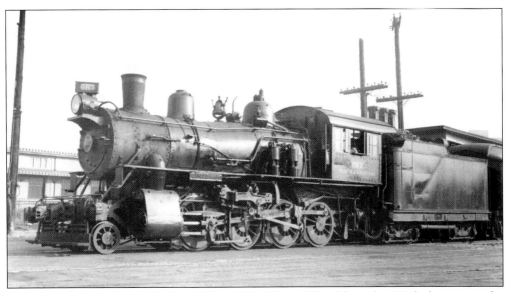

Next came 14 Class W2s, built from 1902 to 1904. These differed from the W1s by having a wider firebox. N&W was pleased with this class and had acquired 202 of them by 1905. The W2s and the Class Ms were the line's main freight power until 1912, when the Mallets began to arrive. After that, they were relegated to branchline service and yard work. (JG.)

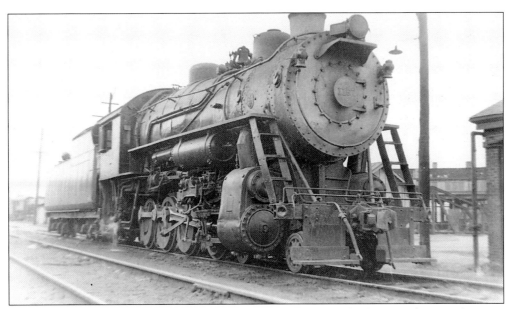

During the early years of the 20th century, N&W designers appeared to be using the manufacturing capability of Roanoke Shops to experiment with designs. After purchasing the largest fleet of 4-8-0 locomotives in the country, Roanoke Shops was asked to build 11 Class M2s, subclassified as M2a, b, and c. These all featured Baker valve gear, and six were superheated, the first for the line. (NK.)

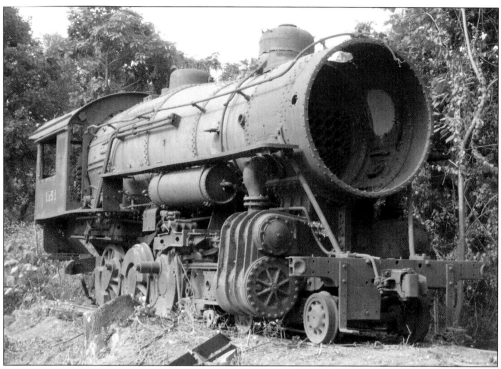

No. 1151, a Class M2a, built at Roanoke Shops in June 1911, soldiered on until 1950 when it was sold for scrap. It waited at the scrap yard for more than 60 years as one of the "Lost Engines of Roanoke," which included two more M2s and other rail equipment. In 2009, all pieces, save one, were rescued. No. 1151 now awaits cosmetic restoration at the Virginia Museum of Transportation. (WM.)

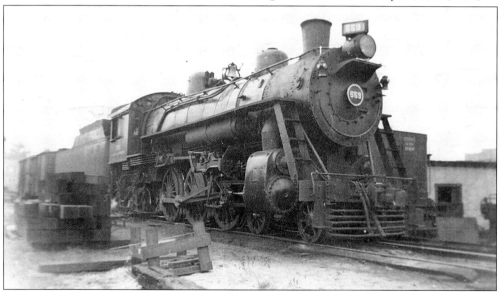

There was a need for stronger power to pull longer and heavier passenger trains. N&W began to acquire 4-6-2 "Pacifics" to fulfill this purpose in 1905. They were referred to as Class E. Unit 559, completed in 1912 and pictured here, was the first of 15 built in Roanoke Shops. By then, the design had been revised to make them 30 percent more powerful; they were classed as E2a. (NK.)

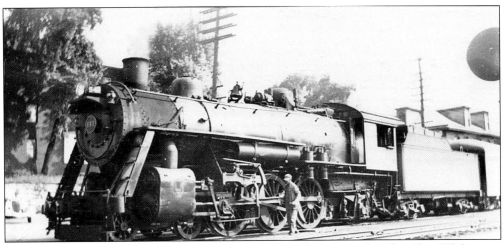

No. 547 was the last of 15 Pacifics completed at Roanoke Shops. It was listed as Class E2b because it had Hobart-Alfree cylinders installed. As more modern power became available, the Class Es were downgraded and performed secondary duties until well after World War II. No. 547 is shown here, late in her career at Hagerstown Maryland, shortly before her retirement in 1951. (NK.)

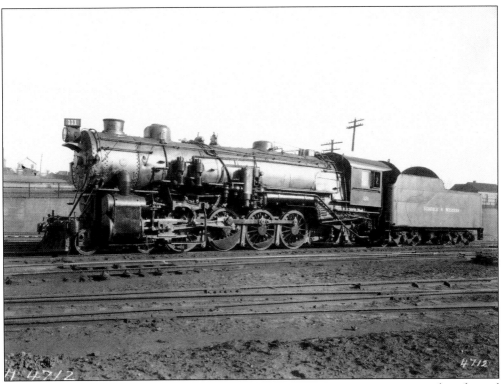

Although the Class Es were an improvement over previous passenger engines and performed well on the flats, the mountainous territory covered by the N&W still required double heading or sectioning of trains. The answer was the Class K1 4-8-2 "Mountain" locomotive, designed by N&W engineers and built by Roanoke Shops. Sixteen of these powerful locomotives, numbered from 100 to 115, were built between 1916 and 1917. (NS.)

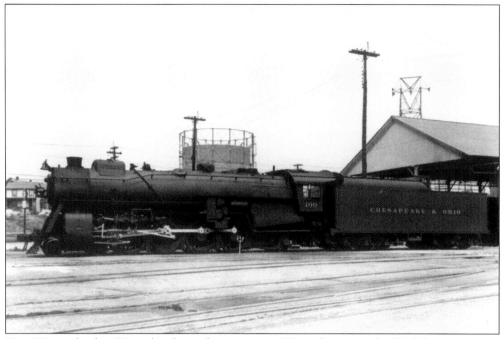

No. 100 was the first K1 and is shown here in May 1955 in the guise of a C&O locomotive for the motion picture *Giant*. Over the years, their original 12,000-gallon tenders were replaced with ever-larger ones. Eight of the class received secondhand 22,000-gallon tenders, originally belonging to Pere Marquette and used on the C&O. (NK.)

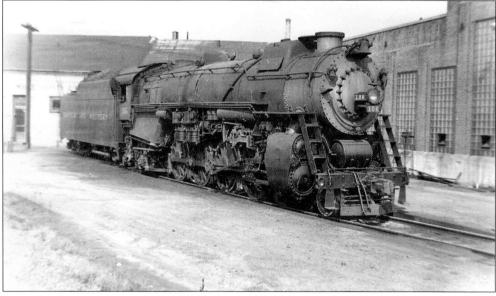

Over the years, many changes were made to the K1s. The most obvious were the square sandbox, moving the light to the center of the smokebox, and placing the bell where the light used to be. The class received extensive overhauls in the 1940s, which included strengthening the frame, new cast cylinders, overhauling the boilers, and so on. The K1s continued to serve until the very end of the steam era. (NK.)

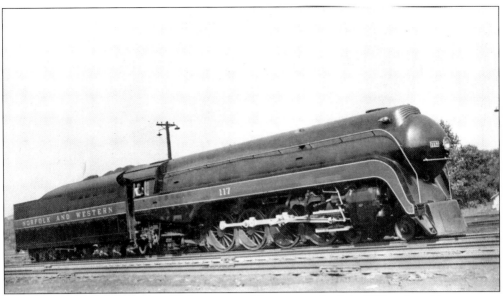

No. 117 is an example of a Class K2 locomotive. This one was built in 1919 and used in passenger service. Brought to Roanoke Shops in 1947 for modernization and rebuild, the locomotive received a new tender and the streamlined shroud. Those units that received this streamlining were almost indistinguishable from a Class J and were referred to as "Capitol K." (NK.)

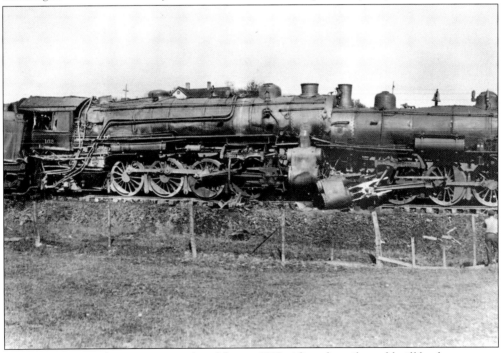

The N&W was a safety-conscious railroad, but in 1922, riding the rails could still be dangerous to passengers and crew alike. ICC figures for the fourth quarter in 1922 show 68 passengers and 516 employees were killed throughout the United States. The N&W lost no passengers but did lose 10 employees, one of whom was fireman Warren Linkous, who was crushed between the tender and Class K locomotive 102 in this head-on collision. (NK.)

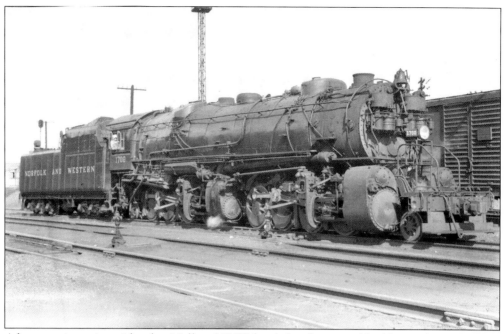

After experimenting with other Mallets, N&W decided to design and build one of its own. Over a period of six years, between 1918 and 1924, N&W built 11 Class Y2 Mallets and acquired 20 others from commercial builders. Production slowed due to World War I and the federalization of American railroads under the United States Railroad Administration (USRA). (JG.)

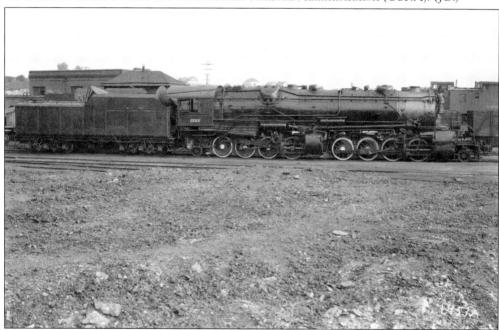

Performance of the Y2 was impressive enough that the USRA used it as the basis for a standardized 2-8-8-2 locomotive for other US railroads. N&W received 50 of these USRA–designed locomotives and referred to them as Class Y3. The Y3s were more serviceable than the parent Y2s, and certain design features were incorporated into Nos. 1705–1710 and were reclassified Y2a. (VT.)

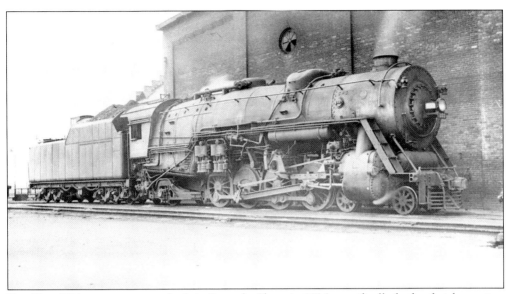

Ten Class K3 locomotives were built in Roanoke Shops in 1926, specifically for fast freight service. This N&W design did not meet expectations. The heavy main rod that connected to the third driver caused severe counterbalance problems and overheating of the driving journal boxes. They also rode rough, and their speed was limited to 35 miles per hour. They were sold off when the Class Js and Class As became available. (NK.)

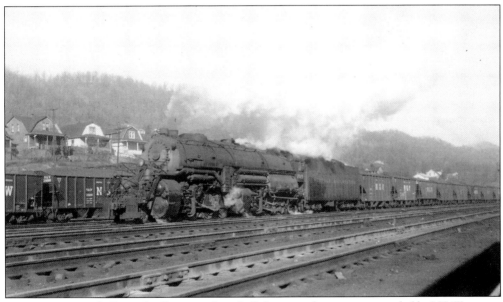

From 1927 onwards, Roanoke Shops produced all the steam locomotives needed by N&W, except for some switchers bought from the C&O. This long line of home-built locomotives began with 20 Y5s, built between 1930 and 1932. The Y5s were next in N&W's quest for heavy road power and incorporated many features later found in the ultimate Mallets, the Y6s. (NK.)

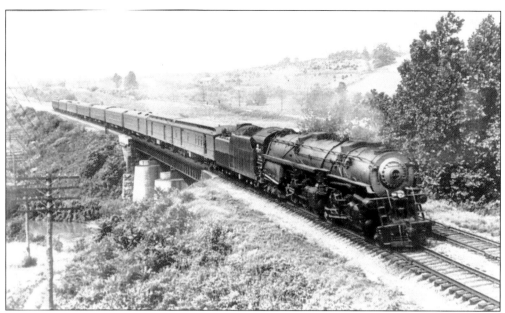

The next class to come off the drawing board was the Class A. The railroad still needed a locomotive with sufficient power to handle time freights in mountainous regions and the necessary speed for the flatlands. The A was a 2-6-6-4, single-expansion articulated locomotive, with 70-inch drivers and the longest wheelbase the system could handle. N&W had found its answer. (NK.)

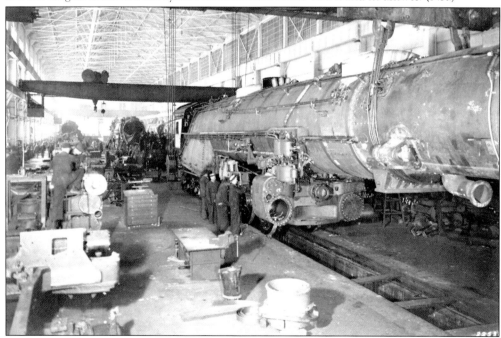

This photograph gives some impression of the size of the Class A boiler, which was 61 feet long and weighed 148,500 pounds, the longest and heaviest ever used by the N&W. The firebox was of welded construction; it had flues 24 feet in length and a combustion chamber of 114 inches. Each of the engine frames was a one-piece casting, and the cylinders integrally cast with the main frame. (NS.)

This photograph shows No. 1218 at the 125th anniversary celebration of Roanoke Shops and emphasizes the articulating front engine. The locomotives were originally equipped with boiler tube pilots, which were later replaced with the cast steel type, seen here. The pilot truck had outside bearings and was of cast steel. The locomotive and tender axles used roller bearings. (WM.)

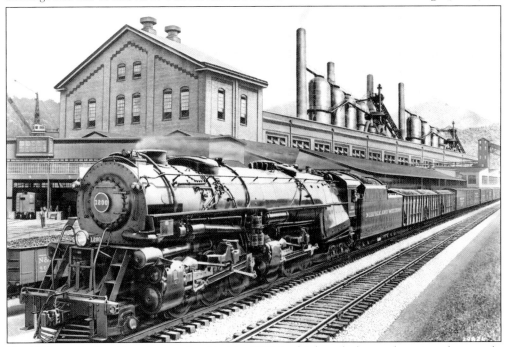

No. 1200 was the first Class A, completed in May 1936. In this heavily doctored wartime photograph, she is seen passing the boiler shop at Roanoke Shops. Because of wartime censorship, numerous smokestacks and meaningless cylinders have been added to the top of the structure and a crane and building addition have been drawn in, all in an attempt to disguise the location. (NS.)

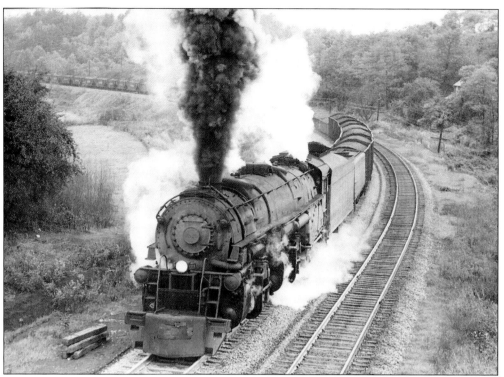

As most railfans know, No. 1218 is the only survivor of the Class A. It is on display at the Virginia Museum of Transportation in Roanoke. Here she is in her heyday, pulling 105 cars of coal weighing 9,510 tons up the 1.3-percent grade just west of Blue Ridge, Virginia. On flat land, it was not unusual for a Class A to pull trains weighing as much as 18,000 tons. (NK.)

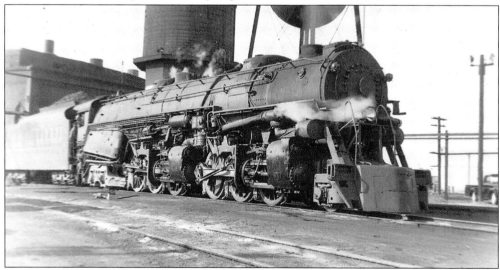

Class As were produced in several different batches between the years 1936 and 1950. The last one built in April 1950 was unit 1242. Numbers 1238 to 1242 were equipped with roller bearings on the main and side rod connections and had lightweight reciprocating parts. This resulted in better availability, lower maintenance costs, less wear on tracks, and longer runs without lubrication. These modifications made a fine engine even more efficient. (NK.)

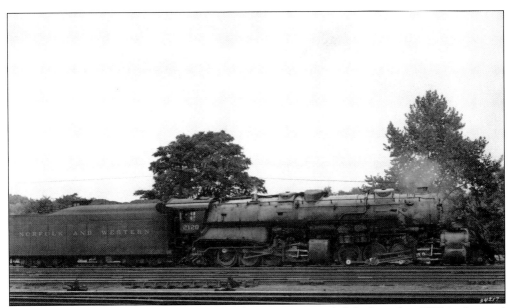

As mentioned, earlier, the N&W–designed Y2 locomotive provided the basis for a USRA–designed Mallet. It was a compound articulated locomotive, which N&W designated as Class Y3. Attempts to improve the locomotive resulted in the Y4 and Y5 classes, the latter built at Roanoke Shops. The culmination came in 1936, when the road engineers designed and Roanoke Shops manufactured No. 2120, the first Class Y6 locomotive. (VT.)

This builders' photograph, taken when the locomotive was completed in September 1936, shows off the arched bridge pipe connecting the two front low-pressure cylinders, which had been used on the previous Y5 class. Other carryovers included the higher-capacity boiler with a 106-square-foot grate area and 18-inch piston valves on the front cylinders. The large single stack had improved drafting characteristics. (VT.)

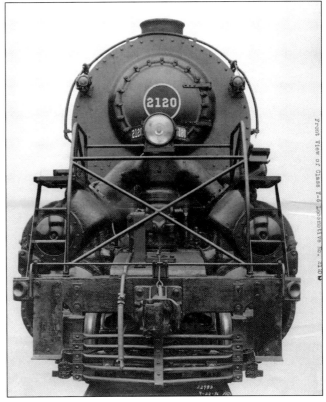

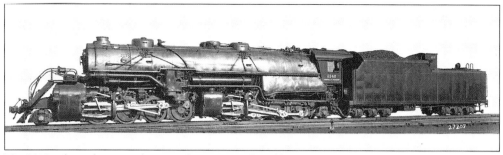

No. 2140 is from the second group of 20 Y6s, produced between 1937 and 1940. N&W's preference for Baker valve gear is seen in this side view as well as the Worthington feed water heater. Roller bearings were used throughout, and the engine frames were single castings with integrally cast cylinders. The front cylinder's bore was 39 inches; the rear had a 25-inch bore. (NK.)

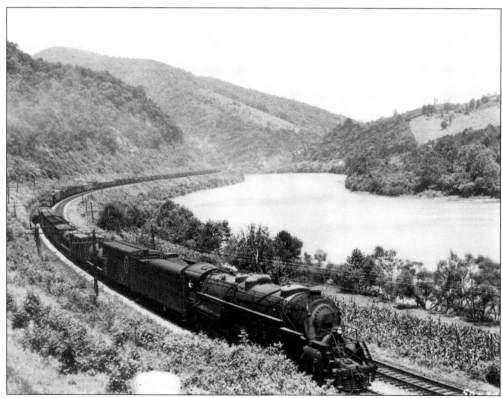

Y6s were made for pulling heavy freight through mountainous territory. Here, No. 2133 demonstrates that ability, pulling time freight No. 86 near Dry Branch, Virginia. Because it could be used for so many duties, the Y6s were the most numerous home-builts in N&W's fleet. No. 2133 was completed in 1938 and is pictured here in the late 1940s. (NK.)

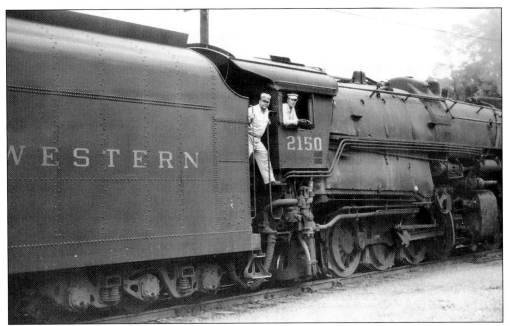

The Y6s were the workhorses of the N&W, and the crews were proud of their engines. They were not built for speed, but for raw, brute power. Nothing else could compare. At Blue Ridge, Virginia, on July 7, 1958, the crew of No. 2150 posed for this photograph. Engineer Irvin O. Woody leans in the window with fireman Nash between the tender and engine. (NK.)

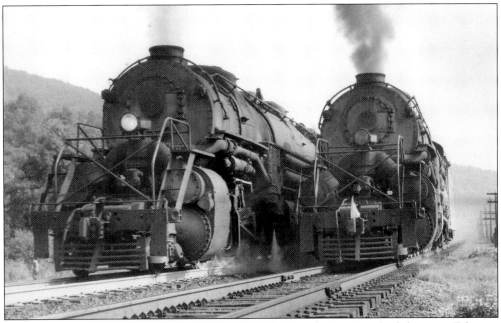

No. 2156 (left) and No. 2158 were part of a group of 16 Y6a locomotives built between February and November 1942. The Y6a differed from the Y6 mainly in the arrangement of the roller bearings. Here, the two locomotives are being used as helpers near Vinton, Virginia. No. 2156 is the only remaining Y6a and is on display at the National Museum of Transport in St. Louis, Missouri. (NK.)

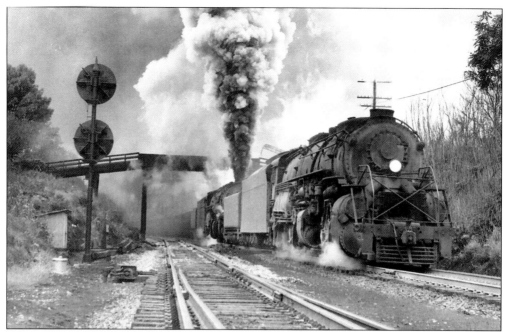

A double header features Y6a 2160 in the lead with Class A 1241 behind. Just east of Blue Ridge Station, it is lugging 135 loaded coal cars to Lambert's Point. The second engine always starts the train, and then the lead engine opens up. The tremendous increase in export coal traffic made these double headers relatively common. (NK.)

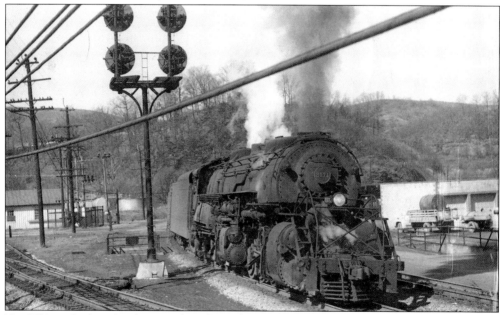

No. 2171 was built in April 1948. Classed as Y6b, it began the last iteration of the Y6 line. The Y6b was built in two different groups between 1948 and 1952; they featured redesigned valve events and larger stacks, with lower back pressure-producing exhaust nozzles. The original Y6 produced 4,400 drawbar horsepower at 20 miles per hour; these improvements increased it to 5,600 drawbar horsepower at 25 miles per hour. (NK.)

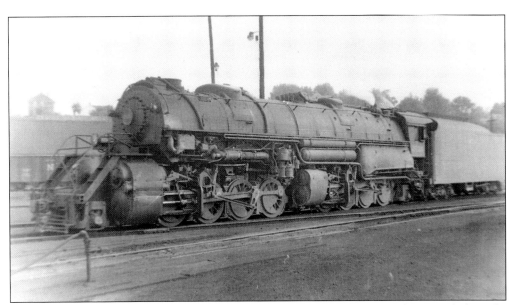

No. 2200 was the last Y6b built in April 1952. The improvements, mentioned previously, brought their tractive effort to a measured 166,000-pound force, making them some of the hardest pulling locomotives ever built. But no matter how efficient they were when they were working, they were far more labor intensive to operate and maintain, and ultimately, that was their doom. (NK.)

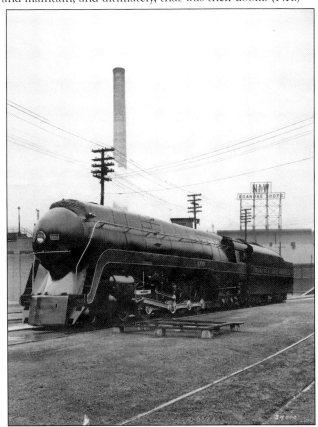

After the first 35 Class Y6s were finished in 1940, the shops began preparations to build what many consider the finest passenger locomotive ever produced. No. 600 was the first Class J, and it rolled out of Roanoke Shops on October 20, 1941. This particular photograph was actually taken 10 years later, at a 10th birthday celebration for the J. (VT.)

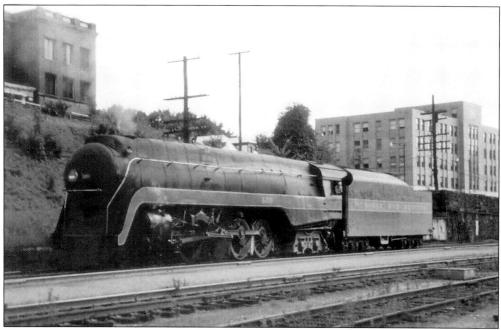

Js were popular with the entire N&W family. Here, No. 600 stands outside the Pocahontas Division office building at Bluefield, West Virginia. The streamlining scheme finally settled on was the third drawn up by Frank C. Noel, of the railway's Passenger Car Department. The first was considered too plain, the second too fancy, and the one chosen was "just right," considered by many as the most beautiful streamlined steam locomotive ever. (NK.)

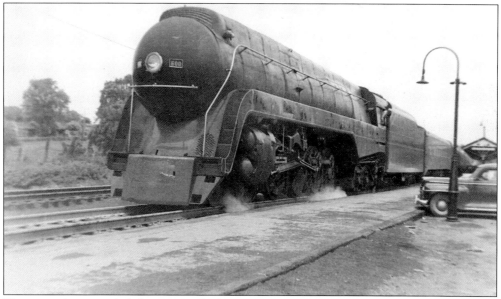

The streamlining included a cast steel pilot with retractable coupler and a bullet-shaped shell that enclosed the headlight and covered the smokebox. Between the nose and pilot was a shield that covered the air pumps and feedwater heater and melded right into the steps and running board. The cowling at the top covered the large stack, sandbox, steam dome, whistle, bell, and safety valves. (NK.)

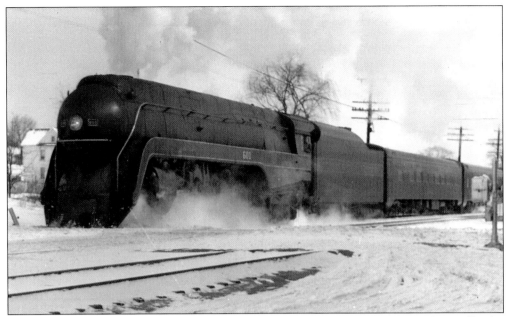

No. 601 was the second J out of the stable, completed in November 1941. Mechanically, the Class J was superb. Their cast steel frames were the longest and heaviest used by N&W. The air reservoir was cast into the frame, which added to the locomotive's appearance. Roller bearings were used on all engine and tender axles, and the Baker valve gear was equipped with needle roller bearings. (NK.)

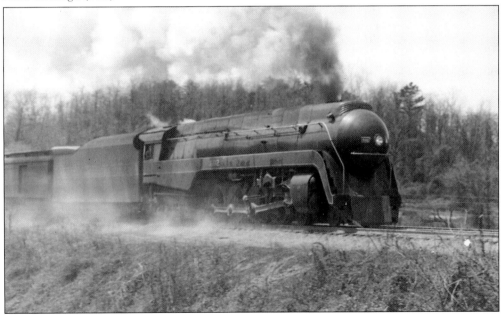

No. 602 is pulling train No. 4, just west of Walton Tower. No. 602 was unique among the Js, being equipped with a trailer booster rated at 12,500 pounds of tractive effort. The booster raised the tractive effort to 85,800 pounds, compared to the normal rating of 73,300 pounds. Later, more tractive effort was gained by raising boiler pressure to 300 pounds per square inch, and the booster was removed in December 1945. (NK.)

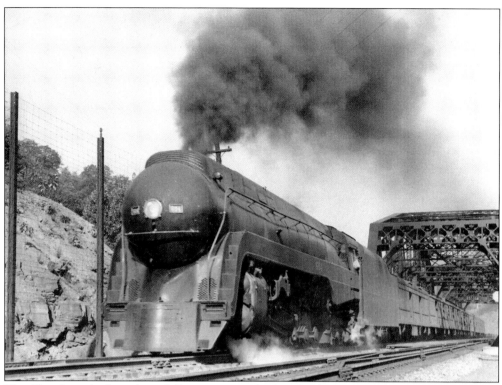

The Class J was built in three different groups, the first five being completed between October 1941 and January 1942. No. 604 was the last of this group and is seen here pulling N&W's famous "name train," the "Pocahontas," over the high truss bridge, which crosses Route 52 at Maybeury, West Virginia. (NK.)

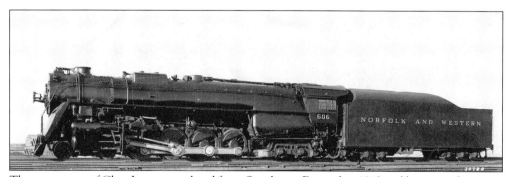

The next group of Class Js was completed from October to December 1943 and because of wartime shortages was built without the streamlined shroud. The Class J1 locomotives also had heavier rods, and floating bushings were used instead of roller bearings. Other changes included the use of alligator crossheads, and the slots on the pilot were left uncovered. (NK.)

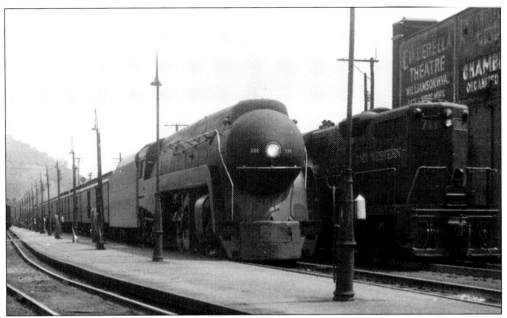

The Class J1s did not serve long without streamlining. By November 1944, all had the streamlining applied, with lighter weight rods, roller bearing valve gear, and a solid pilot installed. With these changes, they were reclassified as Class J. No. 606 is seen here at Williamson, West Virginia, sometime in the late 1950s. It is parked next to one of the diesels, which were slowly taking over. (NK.)

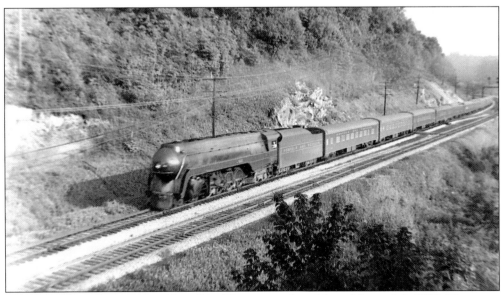

The final Class J locomotives, Nos. 611–613, were produced from May to July 1950. They were built primarily to pull the main line and Bristol locals. In the photograph, No. 611 is seen fulfilling this duty. The 14 Class Js were N&W's primary passenger power, and they handled 84 percent of N&W's passenger traffic in the early 1950s. (NK.)

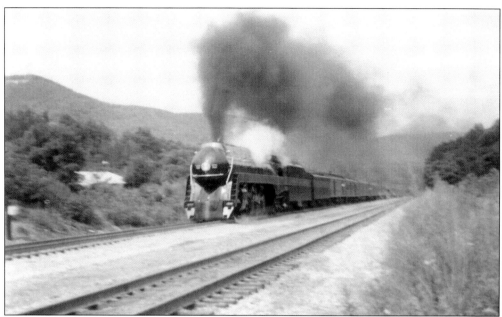

When Norfolk & Western Railway and Southern Railway merged in 1982 to form Norfolk Southern Corporation, Southern had an active steam excursion program in place and a steam shop in Birmingham, Alabama. The only remaining Class J was 611, which was sent to Birmingham for restoration. It moved under steam power for the first time in 22 years on August 14, 1982. (NK.)

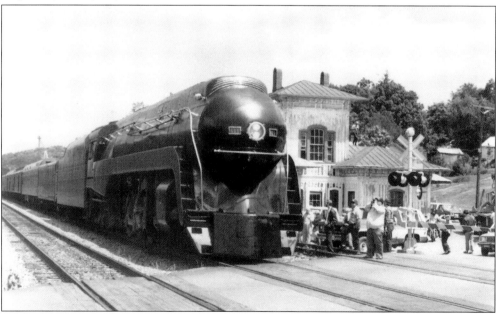

Above, No. 611 stops at Christiansburg, Virginia, during one of her excursions. She continued excursion service for 12 years, thrilling passengers and railfans alike. Class A, No. 1218 was also restored. Excursions pulled by either of these locomotives were extremely popular until the end of the steam program in 1994. Both No. 611 and No. 1218 are currently on display at the Virginia Museum of Transportation in Roanoke. (NK.)

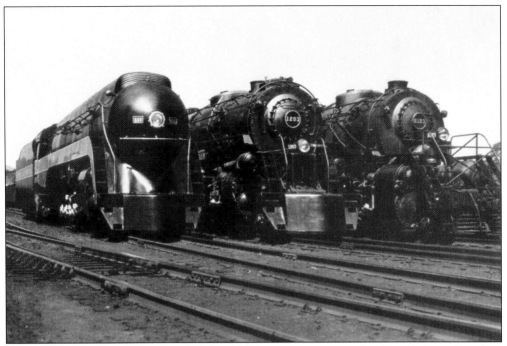

With the Class J (left) pulling the majority of their passenger trains, the Class A (center) as their efficient, general purpose locomotive, and Y6 (right) serving as their heavy hauler, the N&W had a fleet that could meet any needs. N&W produced the three most efficient locomotives of their type ever built. The company was justifiably pleased and proudly dubbed them the "Magnificent Three." (NK.)

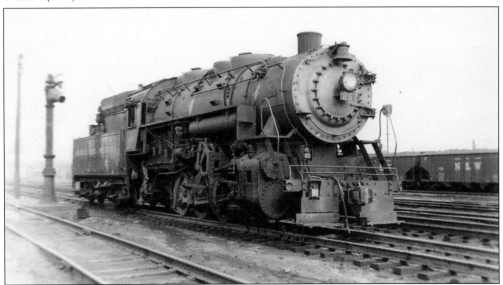

The N&W, like most railroads, did not concentrate heavily on yard engines, using a variety of older classes for these operations. In 1948, Chesapeake and Ohio (C&O) ordered 30 new 0-8-0 switchers from Baldwin. They were put up for sale a year later when C&O decided to dieselize. N&W bought them, and they were put into service in March 1950. N&W was very satisfied with these switchers. (NK.)

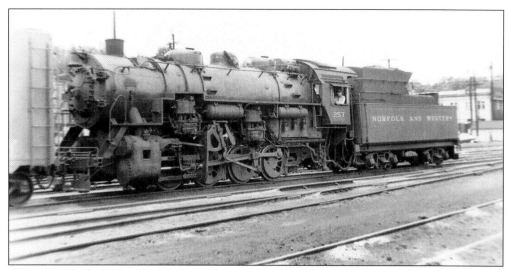

Classed as S1, the 30 former C&O switchers retained their original numbers. The tenders had a high, narrow coal bunker and a low-profile water cistern to aid crew visibility. These switchers were very reliable and could handle long strings of cars with no problem. Their success resulted in the retirement of many older classes of power. (NK.)

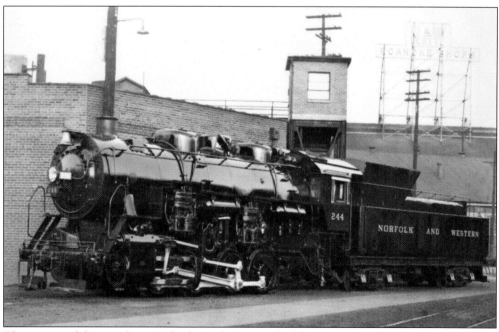

The success of the switchers resulted in a decision to build 45 copies at Roanoke Shops, the last steam locomotives to be built there. The design incorporated minor changes, which resulted in this group being classified as S1a. The last steam-reciprocating steam locomotive built for any Class I railroad was No. 244, the 447th built at Roanoke Shops. It was the end of an era. (NK.)

Five

CHANGING TO DIESELS

Production of new steam locomotives ended at Roanoke Shops in 1953. At that time, N&W had a fleet of modern, coal-burning steam locomotives in place, built to their own design, supplying its motive power needs. Since many steam locomotives served 50 years or more, this fleet was still very young. The primary main line freight locomotives, built for the mountainous regions, were the Y5s and Y6s; their average age was just 12.75 years. The Class As, with an average age of 11 years, hauled the time freights across the flatlands and also pulled some of the fast passenger trains. Finally, for passenger work, the Class Js were the youngest of all, with an average age of eight years. By the end of 1960, they all would be gone.

N&W was reluctant to convert to diesel. Their line had access to abundant coal, and the company had faith in it, both as a fuel and as a source of revenue. In 1952, they tested a Class A against a four-unit, 6,000-horsepower diesel on the flatter portions of the system. They tested the same diesel against a Y6 in the mountainous regions. The criteria for the tests measured the efficiency of the locomotives, including number of cars, tonnage, total time, and speed. By all these measures, the steamers held their own against the diesels and bested them in some areas. But the tests did not include labor costs, maintenance, and operating efficiency. When these were factored in, the steam locomotive simply could not compete.

This chapter presents a glimpse into N&W's early experience with diesels. It illustrates how the shop not only adapted to this form of power, but also gained an expertise possessed by few railroad shops anywhere. The advantage of diesel over steam was so great that the changeover was inevitable. There is no doubt it was the correct decision for the company. But for employees of the railroad industry, it was devastating.

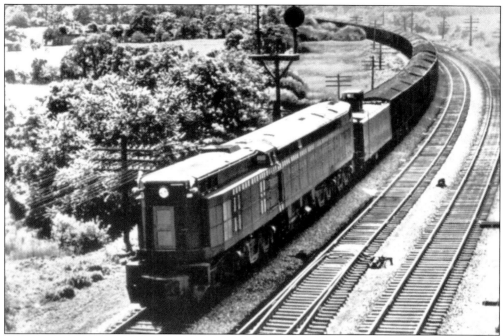

N&W's loyalty to steam power was motivated by their access to an abundant supply of coal. In a final attempt to utilize this resource, N&W took delivery of a steam turbine-electric in 1954. Built by Baldwin-Lima-Hamilton, with a Babcock & Wilcox water tube flash boiler, No. 2300 was named "Jawn Henry." Westinghouse created the electrical system. The locomotive rode on four, three-axle trucks, and with all axles powered, the Jawn Henry was a C-C-C-C locomotive. The locomotive had a number of problems in its short life span. Coal dust contaminated the electrical equipment. The feedwater heater caused trouble, as did the semiautomatic boiler controls. The turbine blades suffered when the locomotive backed heavily into a train. Jawn Henry was mainly used as a "pusher" and was retired and scrapped in late 1958. (Both, NK.)

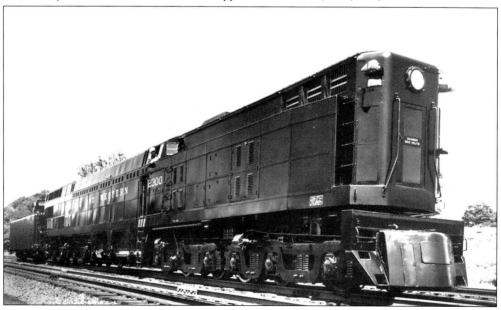

TABLE 6

UNIT OPERATING COSTS PER MILE

FREIGHT, MINE RUN AND PASSENGER SERVICE

STEAM AND DIESEL LOCOMOTIVES

2.6

Accounts	Freight and Mine Run Services	
	Steam	Diesel
Repairs	$1.2720	$.5200
Enginemen	.4022	.4049
Fuel	1.0451	.6101
Water	.0779	-
Lubricants	.0332	.0438
Other Supplies	.0193	.0102
Enginehouse Expense	.3100	.0872
TOTAL	$3.1597	$1.6762

.20 UNIT MIL

Actual ✓

	Passenger Service	
	Steam	Diesel
Repairs	$.7171	$.4000
Enginemen	.3564	.3616
Fuel	.4487	.4651
Water	.0297	-
Lubricants	.0204	.0336
Other Supplies	.0176	.0079
Enginehouse Expense	.0763	.0669
TOTAL	$1.6662	$1.3351

In 1958, N&W had the Electro Motive Division (EMD) of General Motors do a study of the costs and advantages of a complete conversion to diesel power. The report runs over 40 pages, but this one table from that report tells why steam locomotives disappeared from the rails. It had nothing to do with their efficiency at pulling freight; N&W had already proven their steam power in those areas. The critical factors were the facilities, the supplies, and the labor it took to keep them on the road. The figures show that in freight service, it cost only 53 percent as much to operate a diesel as it did for a steam locomotive. The savings was not as great in passenger service, but that was a disappearing source of revenue, and the company knew it. (NWHS.)

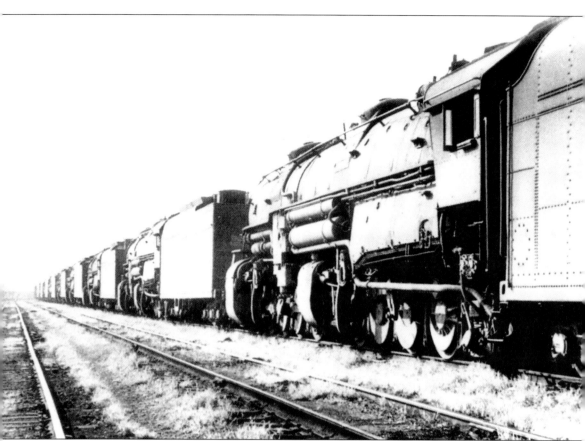

This 1960 photograph shows the "deadline" of Class Y locomotives waiting for the scrapper's torch. Dieselization meant increased operating efficiency for the railroad, but that often translated to lost jobs for employees. National figures from the Bureau of Labor Statistics show that in 1953, there were 1,361,600 people working for the various railroads. By 1965, that number had been cut almost in half to 712,500. No doubt, there were other factors involved in this loss of jobs. Railroad employment had suffered gradual losses for decades before this time and would continue to decline. However, it was 1953 when the first Class I railroad completed dieselization, and by 1965, most of the smaller railroads had done so as well. The industry lost 48 percent of its jobs during this transition period. (NK.)

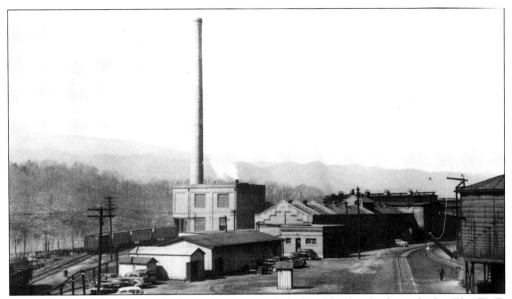

Maintenance and servicing facilities were particularly hard hit by the loss of jobs. The EMD report listed 21 maintenance facilities on the N&W system. Of those, it recommended retaining only three, abandoning one completely and reducing the remainder to simple fuel pads. Most of these facilities, like this one at Shenandoah, Virginia, which employed 100 to 200 people, saw their employees cut by 75 percent or more. (VT.)

An Alco RS-3 sits on the turntable at the west end of Roanoke Shops. The transition to diesel caused shop forces to face a new reality. The shops were no longer a manufacturer of new locomotives. The unique skills needed to build and maintain steam locomotives were no longer needed. Employment was reduced to its lowest levels since Roanoke Shops opened in 1884. (JG.)

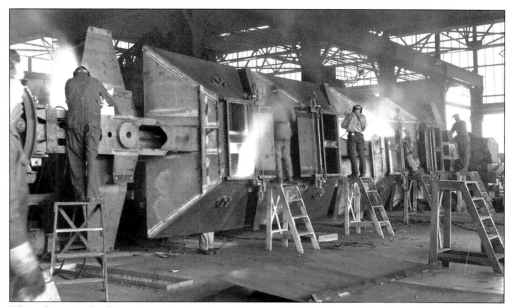

This photograph shows "carmen" constructing an HC-66 covered hopper car. Even though locomotive jobs were being lost, work in the car shop was increasing. Superintendent of shops John Gearhart tried to minimize the hardship on the men by coordinating layoffs in the locomotive department with hiring sessions in the car department. This enabled some of the men to retain employment and helped N&W retain some highly skilled craftsmen. (JG.)

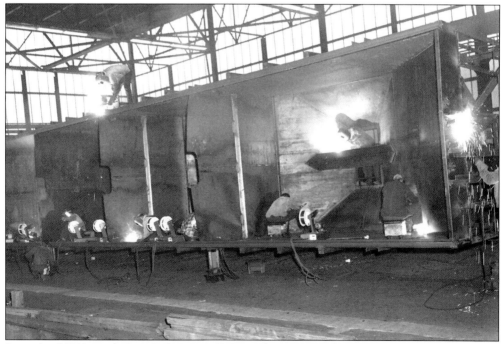

In an April 1982 article from *Railway Age*, B.C. Cook, superintendent of car shops, said that during the transition from steam to diesel, car construction was what kept the other shops open. The foundry supplied castings for cars, as well as locomotives, and some car parts had to be machined as well. The increase in car production prevented the entire facility from closing. (NS.)

John Gearhart went to work in 1923 as a machinist's apprentice; he retired 47 years later in 1970 as the superintendent of shops. He was promoted to that position in 1956 and guided Roanoke Shops through the difficult transition from steam to diesel. He was considered by those who worked for him as one of the most honorable men they had ever met. (JG.)

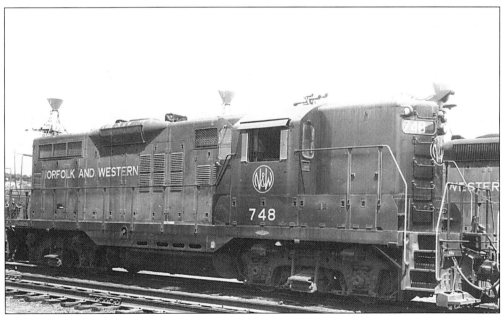

At the time of the 1958 EMD study, N&W already owned 198 diesel locomotives. Of these, 133 were GP-9s, pictured here. More were bought, and they constituted the majority of the early N&W diesel fleet. This locomotive had a two-stroke, 16-cylinder diesel engine, which developed 1,750 horsepower. The engine turned a large generator that supplied electricity to the four traction motors, which moved the locomotive. (JG.)

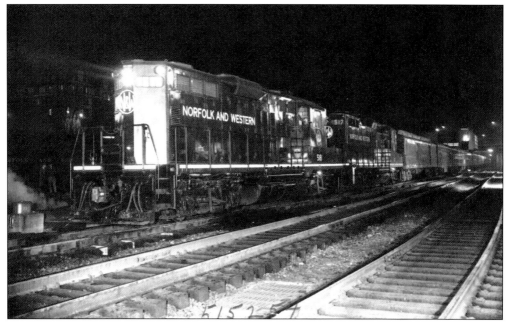

One of N&W's giant steamers could produce more than 5,000 horsepower. A GP-9 produced only 1,750, but several could be connected by a MU (multiple unit) cable to produce whatever power was required. In this photograph, two GP-9s are connected by a MU cable. Controlled by one crew from the cab of the lead locomotive, they operated as one and produced 3,500 horsepower. (NS.)

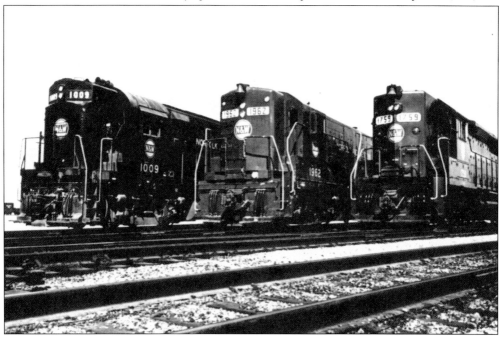

The diesels would not remain underpowered. This group of second-generation diesels consists of an Alco C-425 (left), which developed 2,500 horsepower. In the center is a GE U-28b producing 2,800 horsepower. On the right is an EMD SD-45, which had a 20-cylinder engine capable of 3,600 horsepower. Today, Norfolk Southern owns diesels that can produce 4,500 horsepower. (NS.)

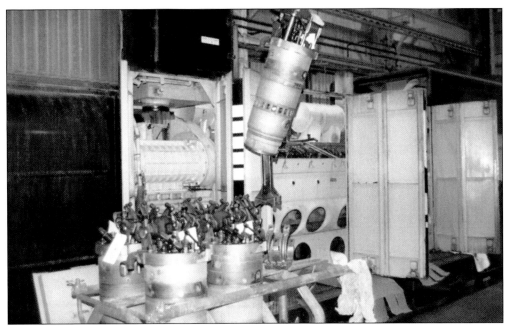

There are few available photographs showing work being performed in Roanoke Shops during the early years of diesel maintenance. This is the System Assembly Shop (SAS) in Chattanooga, Tennessee, showing an EMD power assembly change-out. Work was performed the same in both shops. The engine's 16 power assemblies could be replaced individually, but all were changed during an overhaul. (WM.)

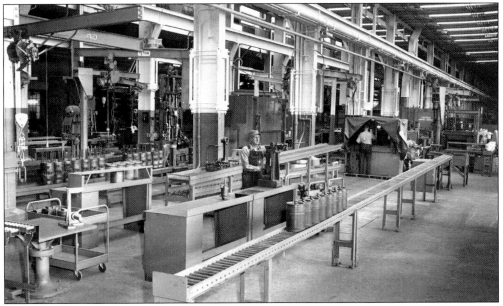

Roanoke Shops set up an EMD power assembly line to recondition used parts and to build their own power assemblies. The employee at center is qualifying a connecting rod. On the conveyor in front of him is a line of pistons already inspected. In the background, the employee in front of the "tent" is using magnetic particle nondestructive testing, which requires a black light to inspect parts for cracks. (NS.)

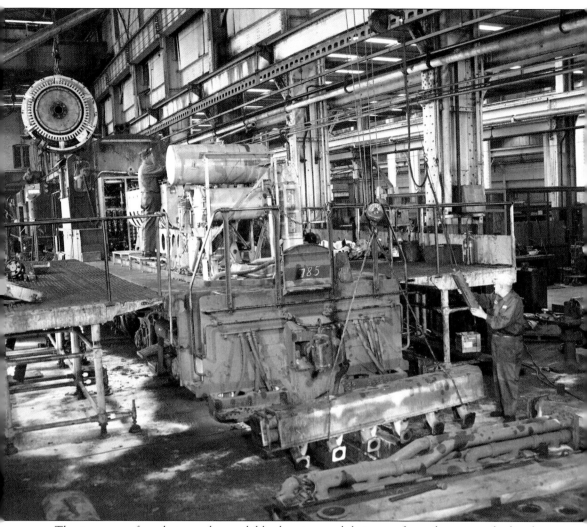

There are very few photographs available showing work being performed on an early diesel at Roanoke Locomotive Shop (RLS). This 1963 photograph shows the abundant overhead clearance at RLS that allowed employees to completely remove the car body. At the top left, the main generator is seen hoisted in the air, while the machinist, on the extreme left (only part of him is showing), gives directions to the crane operator. At center left, another machinist is working on the engine. In the distant background, an employee (probably a boilermaker) is on the roof of an Alco RS11 locomotive, while in the foreground, a machinist lowers the exhaust manifold from that locomotive. Following their practice as a steam shop, RLS classified their overhauls as numbers one through three. Number three was the most thorough, requiring the locomotive to be completely stripped and rebuilt. (NS.)

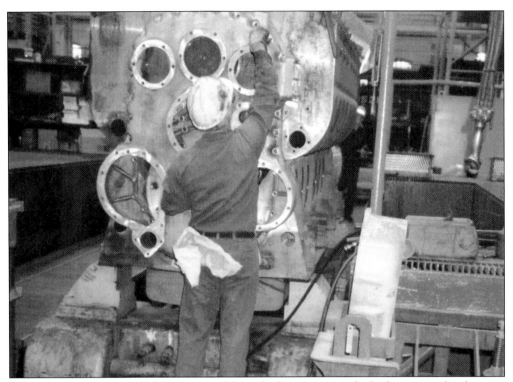

Often the entire engine would be removed from the locomotive and rebuilt on specialized engine stands. In this photograph, a machinist applies an accessory end housing to the front of an EMD engine. The accessory end housing held an oil scavenger pump, the main lube oil pump, two water pumps, and the engine governor. (WM.)

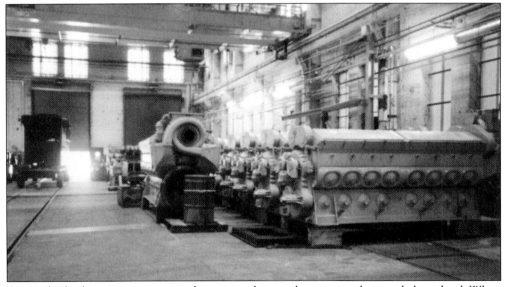

Once rebuilt, the engines were stored, awaiting the next locomotive that needed overhaul. When a locomotive came in, the engine would be removed (to be rebuilt later) and one of the previously completed engines would be installed. This sped up the overhaul process considerably, and the locomotive could be returned to service much quicker. (WM.)

In 1982, Norfolk & Western and Southern Railway merged, creating Norfolk Southern Corporation. Each railroad had its own shops, and the new corporation had to decide how to best allocate the work. The Southern Railway overhaul shop was the System Assembly Shop (SAS), located in Chattanooga, Tennessee. Management saw no need for two overhaul (back) shops, and by the early 1990s, the two shops were competing for the work. SAS, pictured below, being much smaller was at a disadvantage. The realization that one of the shops might be closed caused great stress to the employees, but it should be noted that, when SAS closed, no employees actually lost their livelihood. Some were able to retire, while many others transferred to the nearby Chattanooga Diesel Shop. NS provided adequate expense money for those who chose to move to Roanoke. (Both, WM.)

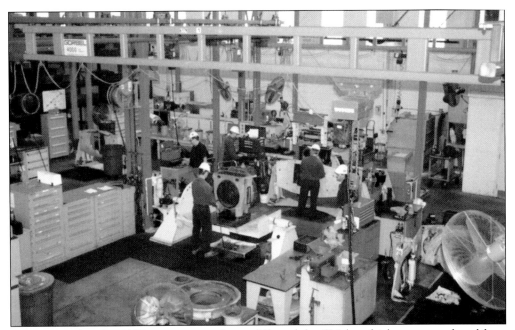

When SAS closed in 1997, nineteen employees followed the 56 jobs, which were transferred from Chattanooga to Roanoke. These jobs included turbocharger rebuilds, which are shown here. Many of the remaining jobs were filled by employees from the Roanoke Car Shop. Employment rose, and the shop expanded to house the extra work. (Tommy Snead.)

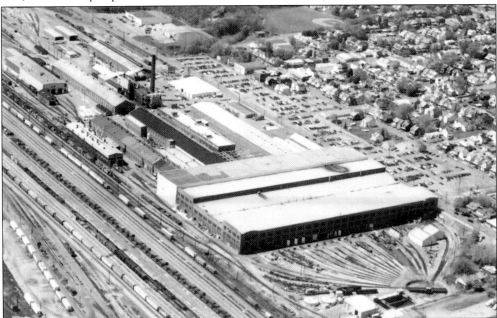

The celebration did not last long. By late 1999, NS had purchased 58 percent of Conrail (CR), including Juniata Locomotive Shop, pictured above. Juniata is a huge back shop located at Altoona, Pennsylvania. Once again, NS had two overhaul shops, but this time, RLS was smaller. Not only that, in order to get the acquisition approved, NS had to make job protection agreements with the Conrail Shops. (NS.)

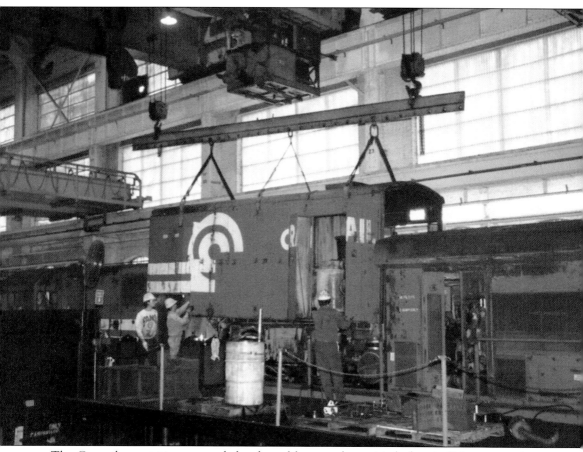

The Conrail acquisition ravaged the shops like no other crisis before it. Prior to acquiring Conrail, Norfolk Southern had the largest cash reserves of any railroad in the country. After the bidding war was over, NS was several billion dollars in debt. Based on their revenue levels, NS figured they could pay off the loans in five years. Then the bottom fell out of the coal business. With money tight and work being reallocated, layoffs were a certainty. Conrail job protection agreements guaranteed the layoffs would occur in Roanoke. In a huge *Roanoke Times* article, written in July 2000, Ralph Berrier Jr. wrote the shops' obituary. In August of that year, the car shop closed, permanently idling 228 employees. By May 2005, only 125 employees were left at Roanoke Locomotive Shops. It would get worse. Many of these men were within two years of retirement. By late 2006, employment was less than 100, including management. (WM.)

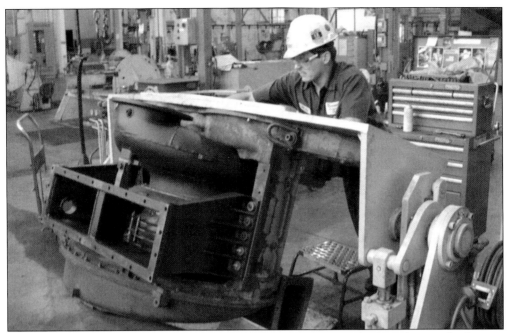

Almost all the jobs that had come to RLS from Chattanooga were subsequently moved to Juniata Locomotive Shop. Turbocharger rebuild remained at RLS, however, and may have been one of the factors helping to keep the shop open. Machinist Mike Faust is seen here applying the final touches to an EMD turbo. By 2004, this work would also be outsourced. (WM.)

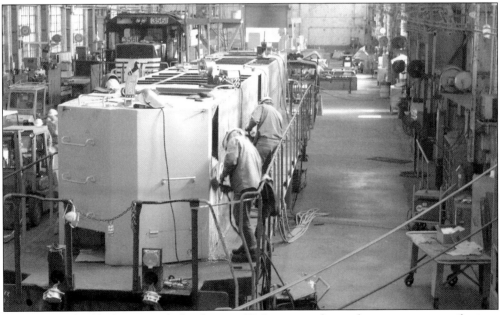

Even during the bleakest period of its history, RLS continued to make important contributions to the company. In the fabrication ("fab") shop, boilermakers Doug DeLong (front) and Barry Hutchens show that RLS still knew how to build a locomotive. This type of locomotive is called a "Slug" and is used in yard service. With just a skeleton crew, the fab shop built several of these units. (WM.)

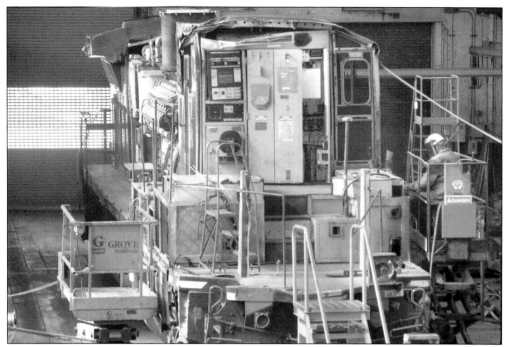

Another important job done in the fab shop was wreck damage. This 2005 photograph shows repairs being performed on a Dash 9 locomotive. Repairing this locomotive required replacing almost the entire car body, which had been destroyed in a wreck. (WM.)

Much of the work that had traditionally been done in the shop, such as diesel engine overhauls and component rebuild, was moved or outsourced. The shop began to specialize in other needed areas. Techniques were developed to repair catastrophic engine failures, such as can be seen in this photograph. Whole sections of damaged engine blocks, properly called a mainframe, could be milled out and a replacement section "stitched" into place. (WM.)

With the damaged mainframe on the horizontal milling machine, in the background, machinist Ridge Smith uses a second machine to mill a replacement section to match the damaged section. The replacement section was cut from a scrap "donor" block. (WM.)

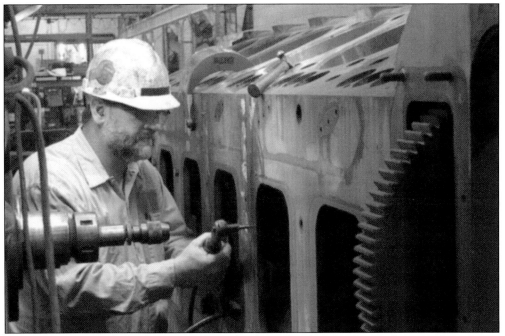

In this photograph, the replacement section has been fitted to the damaged area, and machinist Smith is applying one of the "stitching" bolts. The milling machine is used to bore and tap holes for the stitching bolts, which are applied by hand. The stitching bolts overlap each other and are designed to break off flush. (WM.)

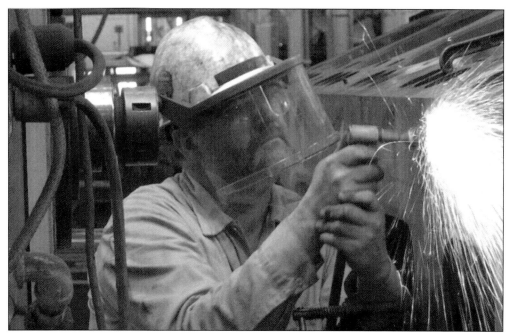

Some minor grinding is required after the stitch bolts break off. After the mainframe is painted, the repair is impossible to detect. It is time consuming, but a new mainframe is very expensive and often very difficult to acquire. Few facilities anywhere can make this kind of repair, and RLS's ability to do so is an invaluable contribution to the maintenance of the NS fleet of locomotives. (WM.)

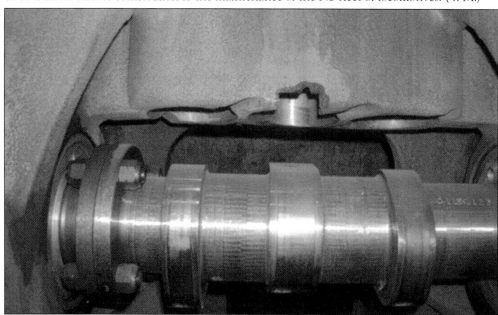

Another unique repair is done on valve tappet bores, commonly called "crosshead" bores. While the damage shown in this photograph is small, many are damaged much worse. RLS has always tried to produce the best quality product and has developed a process to assure that its repairs will save more mainframes from being scrapped. This is another example of specialty work that few facilities can match. (WM.)

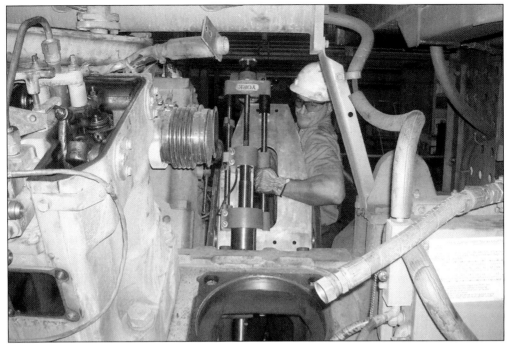

Machinist Matt Monaghan installs the portable boring bar used to cut away the damaged section of the mainframe. The boring bar can be seen extending all the way through the crosshead bores to the area needing to be cut. The mount and setup for this equipment was designed and built at RLS. (WM.)

Once the damaged area is cut away, a replacement section is bolted and stitched into place. In this photograph, machinist David Simmons is tapping the hole for a stitch bolt, securing the end of the replacement section. It is very precise work, and the fact that all drilling and tapping has to be done upside down makes it all the more difficult. (WM.)

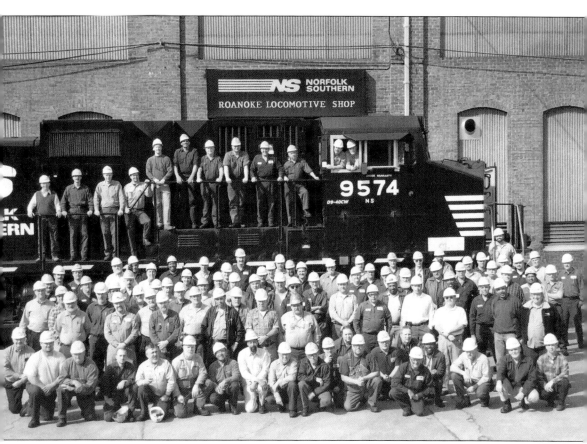

This 2004 photograph shows the men that held the shop together during its darkest days. Morale was at rock bottom, and they felt the company had betrayed them. But somehow, when job assignments were given out each day, they went into the shop and did their job as if nothing were wrong. They consistently produced high-quality repairs in a timely manner. More importantly, they did it safely. From 1999 to 2006, Roanoke Locomotive Shop recorded only 10 reportable injuries. RLS has long been considered a safety leader, and that reputation never faltered during those very bad years. Few other groups of NS employees could have sustained their high standards of safety and production in the face of similar job stress. (Jeff Cutright.)

Six

ROANOKE LOCOMOTIVE SHOPS TODAY

The year 2006 was the low point for Roanoke Locomotive Shop. But by taking on locomotive modifications ("mods") and showing an ability to make repairs to catastrophic engine failures, the shop began to find its niche. More importantly, the work was being done safely. The shop finished 2006 with no reportable injuries. Since then, until the time of this writing, there has been only one injury in the shop.

Certainly, the safety record and quality of work had an influence on management, but there was also a change in management itself. New personnel moved into the top slots in the mechanical department and brought with them a different outlook.

During those difficult years, Roanoke Shops lost many employees to retirement. A few were lost to disability, and some jumped at the chance to transfer to Shafer's Crossing Locomotive Shop when given the opportunity. In all that time, only four men had been hired as replacements. That changed in 2007, when new employees began to fill the shop. By the end of that year, employment was back up to over 150 and still climbing.

New people were hired because of big plans for the shop. A number of projects were developing for the fab shop, and both boilermakers and electricians would be needed there. Also, the new Evolution Series locomotives (called EVOs) were experiencing a variety of problems. These locomotives were manufactured by General Electric (GE) and featured a new German-designed engine and a new computerized control system. GE was recommending a number of modifications based on their experience with other railroads. Machinists and electricians would be needed to do that work.

This chapter provides insight into some of the work currently going on at Roanoke Locomotive Shop (RLS) and why there appears to be a bright future ahead.

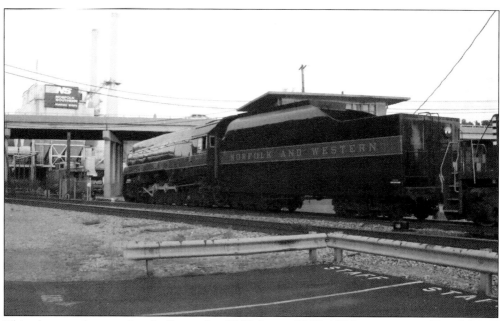

This photograph was taken in September 2007 during RLS's 125th anniversary. To celebrate, the Virginia Museum of Transportation permitted No. 611 and No. 1218 to come "home." The worst was over, and NS management had concluded that having two back shops was not such a bad thing. With Juniata doing the majority of overhauls and RLS doing specialty work, each shop found a place where it could serve the company's needs. (WM.)

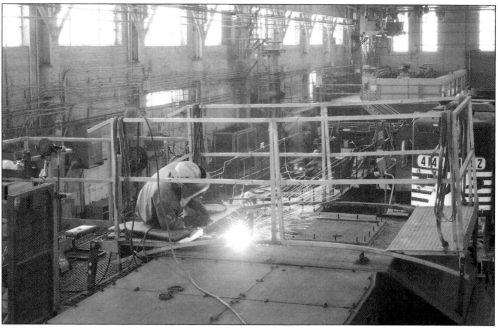

Since 2007, a great deal of work has come to the shops and the workforce has doubled. Many of the new hires have been boilermakers. Here, an employee is modifying the roof of a locomotive to accept an air conditioner. Note the boxing ring–style fall protection, which allows the employee to work on top of the locomotive without the need of a harness. (WM.)

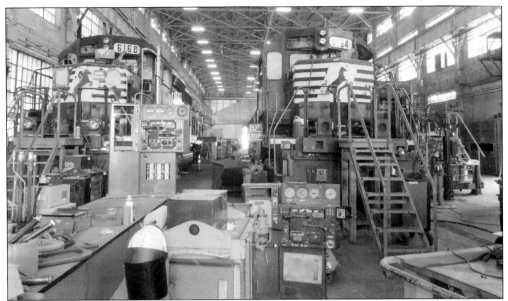

Due to the success of the "slug" project, "cab mods" for GP38-2s and SD40-2s were awarded to the fab shop. These locomotives came into service in the early 1970s but have proven so reliable their service life is being extended. GP38s are very useful in yard service, and the SD40s are greatly appreciated as helper units on steep grades like the Horseshoe Curve near Altoona, Pennsylvania. (WM.)

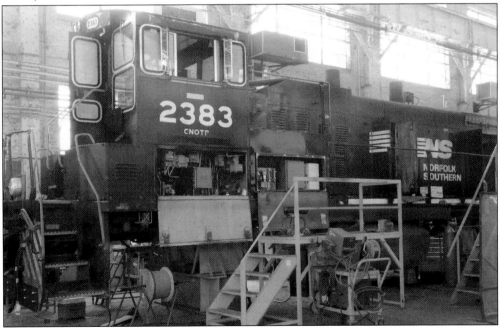

Similar work extends the life of MP15 switch engines. This project involves replacing the generator with an alternator, upgrading the electronics, adding air-conditioning, and replacing the batteries with a unitized battery. The unitized battery alone saves a great deal of time during maintenance, taking only about an hour to change out. Adhesion tests of the modified locomotive have shown a great increase in performance. (WM.)

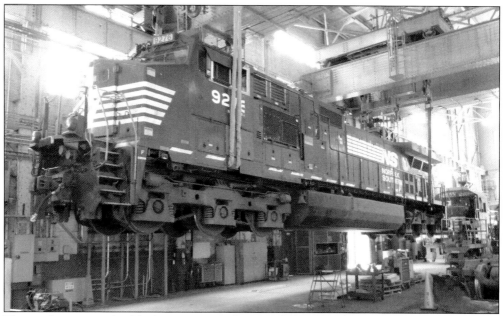

The track entering the fab shop was recently extended to exit the other end of the building. Although this improves work flow, locomotives needing extensive repairs or modifications are simply picked up and placed where needed. Employees refer to this as "flying" the locomotive, and the locomotives seen on the previous two pages were all examples of this practice. Juniata is the only other shop on the system with this capability. (WM.)

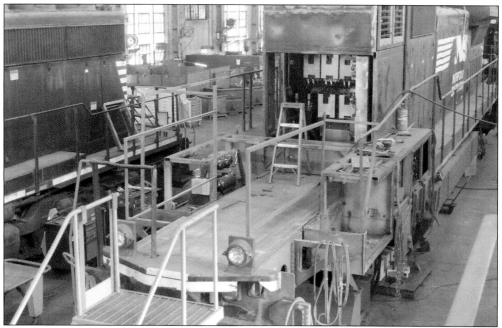

The Dash 8.5 ("8 'n half") project is shared between the diesel shop and fab shop. It is another project designed to extend the life of older locomotives. Basically, it remanufactures a locomotive throughout to modern standards. The fab shop's share of this work involves modifying the car body as needed and applying a new wide-body "comfort cab." (WM.)

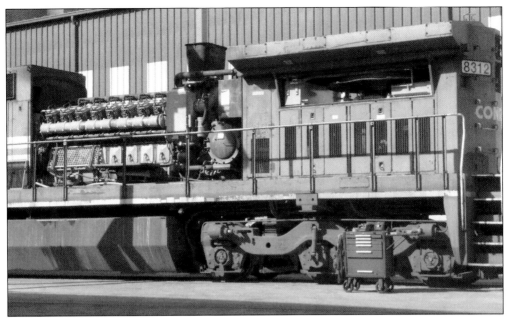

The Dash 8.5 project brings older but still useful locomotives up to current EPA standards. For the diesel shop, that means installing a more modern engine with electronic fuel injection and electronic control system. Shop forces collaborated on the design of a split cooling system, which lowers combustion air temperature. These improvements were tweaked on 8312 until it met EPA standards. (WM.)

With the system perfected, production of Dash 8.5 locomotives is a steady part of RLS's workload. In addition to the improvements mentioned, the trucks and traction motors are also reworked and the locomotive rewired. All this brings a 1980s design into the 21st century. RLS's ability to design and implement this type of modernization makes a valuable, cost-effective contribution to Norfolk Southern. (WM.)

With microprocessor controls, electronic fuel injection, various sensors, and computerized troubleshooting, knowledgeable electricians are a vital part of today's maintenance requirements. In this 2006 photograph, electricians Ryan Palmer (foreground) and Tony Witcher wire contractors into a newly built slug. The shop suffered a real loss when Witcher succumbed to cancer just a few years after this photograph was taken. (WM.)

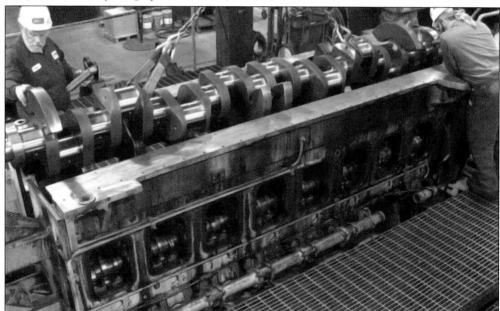

Another unique tool available to RLS is its engine line. It is designed to be ergonomic and safe. The platforms will raise about one foot above the scaffold level and will lower about two feet below the scaffold. The engine stand will rotate the engine a full 360 degrees. Here, with the engine upside down, machinists Jody Bethel (left) and Jon Hendrickson install a crankshaft in a GE engine. (WM.)

RLS continues to build GE power assemblies, though production is down from previous levels. In this photograph, machinist Randy Stump is using a bore gauge to qualify a cylinder liner for a GE 7FDL engine. Parts from engines that have been torn down are stripped and cleaned. To "qualify," they go to the build-up area where they are checked to ensure they meet correct specifications. (WM.)

The white appearance of the liners in this photograph is from frost. After qualification, the liners are placed in a subzero freezer, where they remain overnight at negative 100 degrees Fahrenheit. The water jackets are turned upside down, as shown here, and the frozen liners are inserted. Machinist Brian Porterfield uses the press to ensure they are seated. The liners expand as the temperature normalizes, guaranteeing a tight fit. (WM.)

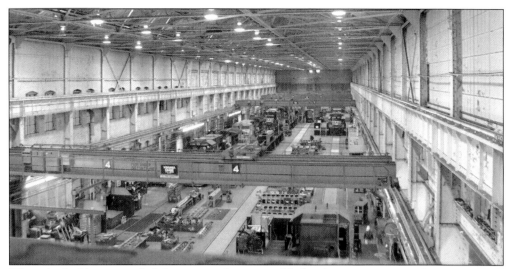

When this building was called the erecting shop, it was filled with steam engines under construction. It is now the diesel shop, and its cavernous interior and three flow-through tracks provide for efficient work flow. Even though it is large, the amount of work that has recently come into the shop makes it seem cramped at times. Compared to the recent past, it is a good problem to have. (WM.)

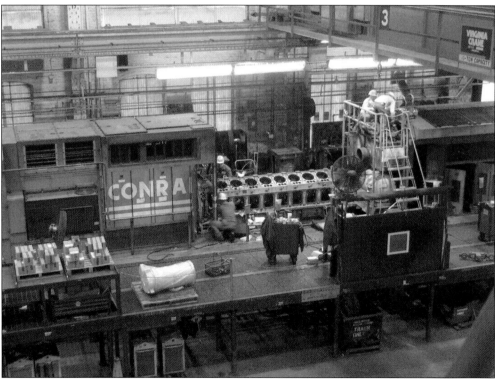

RLS still does several overhauls each month. In this photograph, pipe fitters are using the overhead crane to change a "V" valve on the right, while in the center of the photograph, machinists work on camshafts. All power assemblies have been removed, and rebuild work is progressing. Note the fall protection platform provided for the pipe fitters. (WM.)

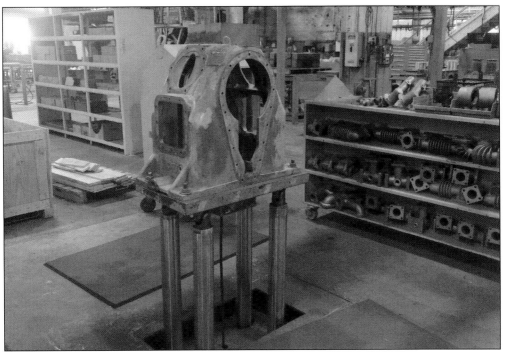

Air compressor work was outsourced several years ago but has recently returned to RLS. The air compressors are stripped and rebuilt on these home-designed air compressor stands. The stands rise up out of the floor to a comfortable working height. The independent posts allow the employee to tilt the air compressor block in any manner desired to make the work ergonomic and safe. (WM.)

One of the most important and challenging jobs undertaken by RLS is heavy repair of GE Evolution locomotives. EVOs have a German-designed engine, which required learning new maintenance methods and the purchase of a whole new set of tooling. RLS employees pursued this work when it first became available. They were the first to embrace work on this new engine and are currently considered the experts. (WM.)

The EVO engine requires much more precise maintenance than other engines and uses a different form of torquing, called "tensioning." Instead of running the nut down the stud to tighten, the hydraulic tensioner stretches the stud, then the nut is run down, hand tight. When the stud is released, the nut prevents it from relaxing. Machinist Larry Dawson is applying the tensioner in this photograph. (WM.)

EVO locomotives were of a new design and suffered many "teething" problems. One of the most serious issues was failure of the "O" rings around the cylinder liner. These O rings are an internal water seal, and their failure could contribute to serious engine damage. In this photograph, machinist Jim Whitt is cleaning one of the O ring grooves using a rope soaked in solvent. (WM.)

At first, RLS followed the manufacturer's recommendation and made the repair without removing the power assembly as seen in the previous photograph. After experiencing repeated failures, shop forces designed this test stand to disassemble the various pieces, clean them thoroughly, and test them after the repair. The test stand has since been patented by Norfolk Southern. (WM.)

RLS bought the tooling, and employees learned the technique for removal and application of the EVO flywheel. This job is so specialized that, with the exception of the manufacturer, no other facility anywhere can do it. The flywheel is not bolted or keyed to the crankshaft. It is hydraulically "floated on" and grips it with such pressure that it transfers 4,400 horsepower to the alternator without slippage. (WM.)

Machinist Jody Bethel installs the flywheel safety cage. The flywheel grips the crank tightly. If the flywheel is not fully normalized when the hydraulic pressure is released, it can pop off. An employee suffered serious injury when this happened at the manufacturer's facility. If it pops off, the force of release is tremendous. This safety cage weighs nearly 2,000 pounds and is designed to catch the flywheel if the worst happens. (WM.)

The latest sign of confidence in the shop is this Rottler CNC line-boring machine. While very expensive, the machine will pay for itself by enabling the shop to repair main bearing bores on any type of engine owned by Norfolk Southern, including EVO engines. The machine is computer controlled, and once the mainframe is positioned, the computer program will cut the bores automatically. (WM.)

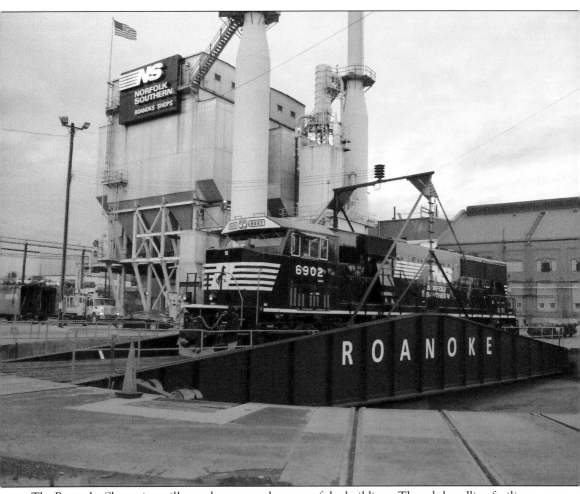

The Roanoke Shops sign will soon be mounted on one of the buildings. The ash-handling facility on which it is seen here is no longer used and was torn down in August 2013. It will be replaced by a pedestrian bridge to allow employees to enter the complex without having to cross main line tracks. Roanoke Shops has more than 130 years of proud history behind it. During these years, the employees have consistently demonstrated pride in workmanship and dedication to their jobs and the company. The shops' history as a manufacturer make employees confident they can design and build new tools to meet whatever challenges come their way. In addition to these qualities, the shops have long been recognized as a leader in safety. Safety has permeated the culture throughout Norfolk Southern, and the record shows that Roanoke Shops employees are still the champs. In October 2013, they surpassed six years and two million man-hours without an injury. Roanoke Shops has faced closure three times, and three times the employees have proven they are loyal, proud, innovative, and able to produce workmanship with unmatched superiority. It is likely they will have a long and bright future. (WM.)

DISCOVER THOUSANDS OF LOCAL HISTORY BOOKS
FEATURING MILLIONS OF VINTAGE IMAGES

Arcadia Publishing, the leading local history publisher in the United States, is committed to making history accessible and meaningful through publishing books that celebrate and preserve the heritage of America's people and places.

Find more books like this at
www.arcadiapublishing.com

Search for your hometown history, your old stomping grounds, and even your favorite sports team.

Consistent with our mission to preserve history on a local level, this book was printed in South Carolina on American-made paper and manufactured entirely in the United States. Products carrying the accredited Forest Stewardship Council (FSC) label are printed on 100 percent FSC-certified paper.

MADE IN THE USA